POSTCARD HISTORY SERIES

Plymouth
IN VINTAGE POSTCARDS

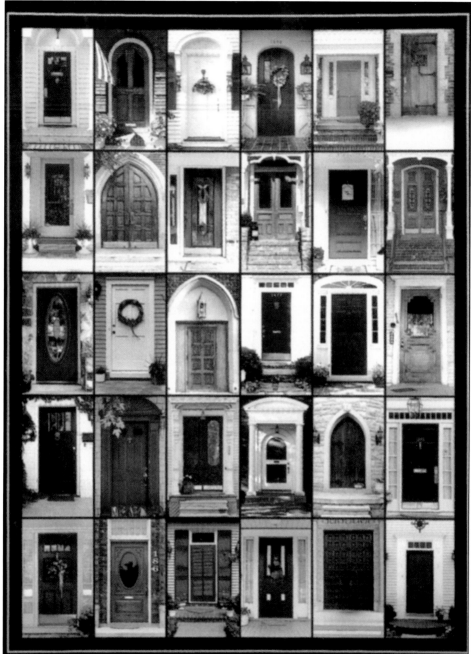

Doorways of Plymouth

PHOTOGRAPHY BY JIM ALLOR

DOORS. One way to see the personality of a city is to get a glimpse of its doorways. Plymouth displays a wide variety of architectural design throughout its streets and on this contemporary postcard. (Used with permission of photographer Jim Allor; from the collection of the author.)

POSTCARD HISTORY SERIES

Plymouth

IN VINTAGE POSTCARDS

Elizabeth Kelley Kerstens

ARCADIA
PUBLISHING

Published by Arcadia Publishing
Charleston, South Carolina

Printed in the United States of America

Library of Congress Catalog Card Number: 2003103502

For all general information contact Arcadia Publishing at:
Telephone 843-853-2070
Fax 843-853-0044
E-mail sales@arcadiapublishing.com
For customer service and orders:
Toll-Free 1-888-313-2665

Visit us on the Internet at www.arcadiapublishing.com

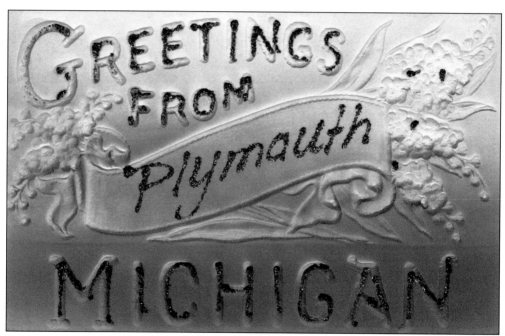

GREETING CARD. Postcard greeting cards were very popular in the early years of the twentieth century. Postcard printers got very elaborate with their designs, using embossing techniques and even glitter, as in the postcard above. This card was generic for Michigan, and the town was written in glitter in the ribbon. Glitter was also used to shade the embossed letters.

CONTENTS

Acknowledgments 6

Introduction 7

1. Trains 9

2. Businesses 15

3. Buildings 35

4. Streets 55

5. Scenery 89

6. People 105

7. Recreation 115

Index 125

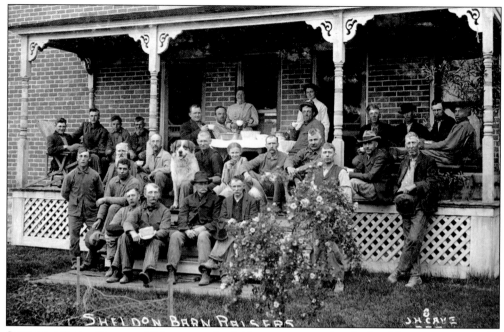

SHELDON BARN RAISERS. This group of neighbors came together for local barn raisings and for the follow-on festivities. The men raised the barn and sipped on cider while the women made the dinner and shared local gossip.

ACKNOWLEDGMENTS

As in any project of this magnitude, there were numerous people that assisted me by finding postcards, finding information, reaching deep into memory banks, and just generally being helpful. In particular, I would like to thank Beth Stewart, Director of the Plymouth Historical Museum, for all of her support, knowledge, and assistance. The volunteers that work with me in the Museum Archives were particularly helpful in ferreting out details. Thanks to Marilyn Erps, Janice Karrer, Charlene Kenny, Dan and Lena Packer, and my mother-in-law Helen Kerstens. Thanks also to those with memories of the Plymouth area who shared their recollections, including Howard "Howdy" Schryer and Graham and Bea Laible. Several postcard enthusiasts came forward and shared their images to be used in this book. Their contributions are noted in the text. The bulk of the images that appear in this book are from the awesome collection of the Plymouth Historical Museum. And last, I'd like to thank my husband, Marty Kerstens, for his unfailing support of my myriad projects and for proofreading this book.

INTRODUCTION

It wasn't until 1898 that Congress passed legislation allowing the private printing of postcards, which was the name chosen to distinguish them from the government's postal cards. The new cards didn't have imprinted postage, but contained the phrase: "Private mailing card—authorized by the Act of Congress, May 19, 1898." The cards required a penny postage within the U.S. The same year, the Rural Free Delivery, or RFD, system was established, which allowed people in rural areas to send and receive mail without having to travel great distances. Prior to RFD, free delivery was only provided to homes in towns with more than 10,000 residents. Both the Village of Plymouth and Plymouth Township residents would not have received free delivery until the advent of RFD, meaning the residents would have had to pick up their mail at the Post Office. Even with RFD, messages still had to be printed on the illustrated side of the postcard until 1907, when the postcard back was divided.

The U.S. followed England, France, and Germany in allowing the back of the postcard to be divided in 1907. With the division, the message could be written on one half of the back and the address on the other half, as postcards are printed today. This change ushered in the golden era of post cards, which didn't slow down until the advent of World War I. One of the reasons the golden era did slow down is that prior to World War I many postcards were printed in Germany, where the printing methods were regarded as the best in the world. With the threat of war looming and import tariffs on postcards, this golden era was brought to a close.

The period of 1916–1930 is considered the White Border or Early Modern Era of postcards. American technology advanced during this period, allowing us to produce quality postcards. The American public's tastes changed, however, and production declined as demand declined. Most of the cards during this era were printed with white borders around the picture.

The Linen Card Era lasted from 1930 to 1945. Technology again advanced during this period, which allowed postcards to be printed on a linen-like card stock, with brilliant colors. Cards with scenes from life in small towns were popular, as were comic postcards.

Photochrome postcards are the type of postcards we are all familiar with today. They are the best reproductions in the history of postcards and their use spans 1939 to the present. In the earlier half of this era, postcards were primarily three and three-quarter by five and five-eighths inches. In the latter half of the era, however, postcard sizes have increased to the standard four by six inch size, and in many cases even larger.

Real photo cards often are hand tinted in great detail and are images of people and localities.

Photographers took pictures of their local area and printed them on special paper with postcard backs. Or, people could take pictures in to be developed and printed with postcard backs. Many of these photos are one-of-a-kind and were not sold but may have been sent to friends or relatives. They were not mass-marketed, but were sold locally or saved for posterity. Many of the postcards in this book are real photo cards either created by local photographers or printed for individuals. They're easy to spot. The cards with handwriting on them, or the ones with local people in them would be real photo cards.

My love of postcards started when I was about six years old. My mother thought I needed something to collect so she handed me a stack of postcards she had from her family and her home town in New Jersey. Since that time, I've indiscriminately collected any and all postcards sent, bought, or given to me. My collection covers literally the whole world and numbers in the 5,000 range. They are sorted by state and by country, which made the search of my collection for postcards from Plymouth that much easier. Unfortunately, I only had a few of my adopted home town, but the Plymouth Historical Society Museum has hundreds of postcards—a fact that has intrigued me considering the size of this area. Plymouth Township covers nearly sixteen square miles, with the City of Plymouth taking up about 2.2 square miles with the township area.

As I wrote in my first book on Plymouth, "Since its founding in 1825, Plymouth has been a thriving community with many activities for residents and more than its share of innovators." The pages of this book are filled with scenes of the community and its livelihood. In 207 postcards, you'll see views of the downtown Plymouth area, the side streets, the businesses, the buildings, the people, the scenery, and the recreational activities. Most of the postcards date between 1900 and 1930, the heyday of postcards. But some show Plymouth in the 1940s, the 1960s, the 1980s, and even just a few years ago. When possible, I've tried to show similar views of certain areas, such as downtown Plymouth, over the years. I am forever indebted to the forward-thinking founders of the Plymouth Museum, and all of the generous people that have donated their precious possessions to the Museum so that a book of this magnitude could be compiled.

Enjoy Plymouth, old and new!

One

TRAINS

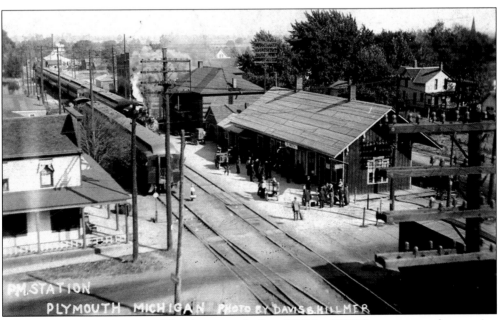

PERE MARQUETTE STATION. The depot was built *c.* 1890 in Old Village to serve the growing passenger rail service from Plymouth to other parts of the state. Plymouth has been fortunate to have two rail lines crossing just outside of the village, allowing rail accessibility in all four compass directions.

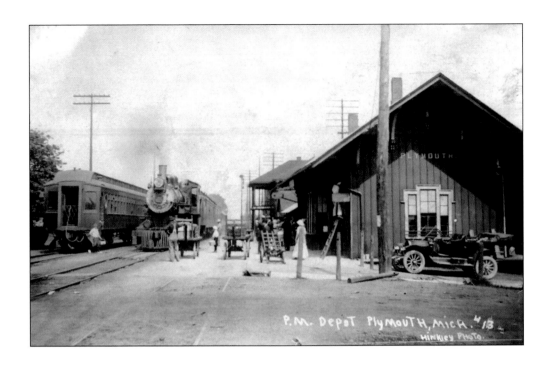

PERE MARQUETTE DEPOT. In 1910, the depot operated under the supervision of Henry Robinson (above). Frank Pierce's Restaurant was adjacent to the depot from 1909 to 1920 (below).

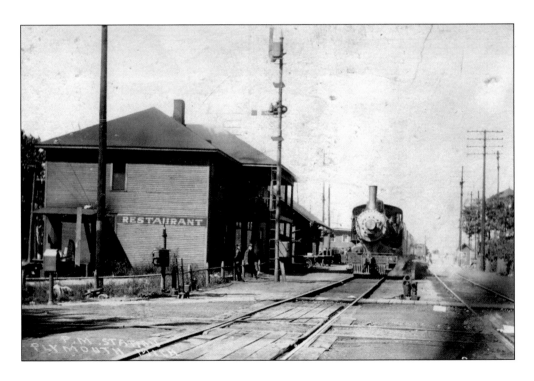

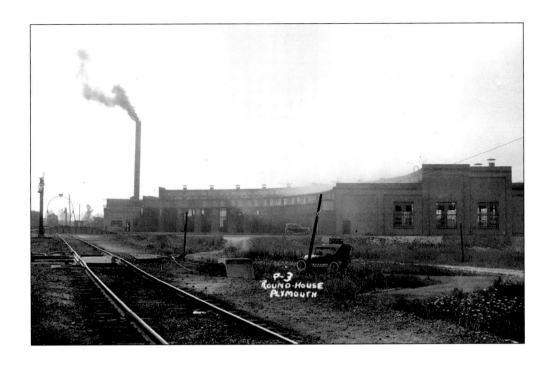

PERE MARQUETTE. The Pere Marquette Round House was at the junction of the east-west and north-south rail lines in Plymouth (above). The Pere Marquette Railroad Yards were quite busy with both freight and passenger trains (below).

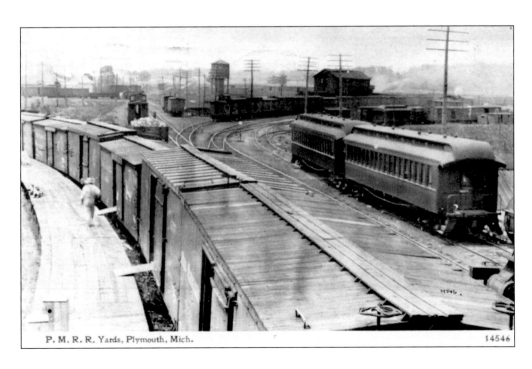

P. M. R. R. Yards, Plymouth, Mich. 14546

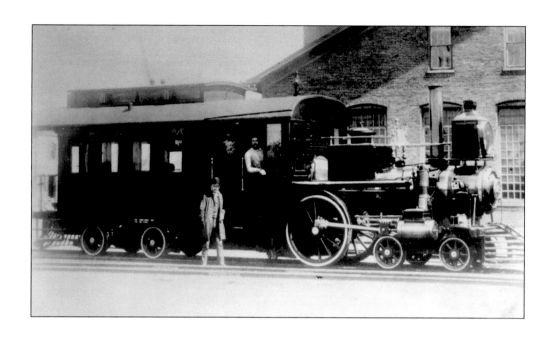

PERE MARQUETTE. The Flint & Pere Marquette Railroad engine "Peggy" (above) was built in 1873. Before 1890, the Flint & Pere Marquette Railroad took over from the original owners of the line, the Holly, Wayne and Monroe line. In the postcard below, a later Pere Marquette engine and passenger train stops at the depot in Plymouth around 1910.

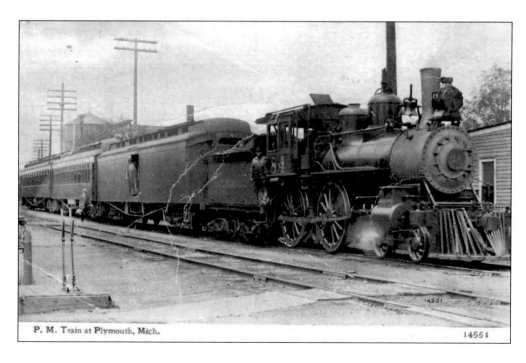

P. M. Train at Plymouth, Mich. 14551

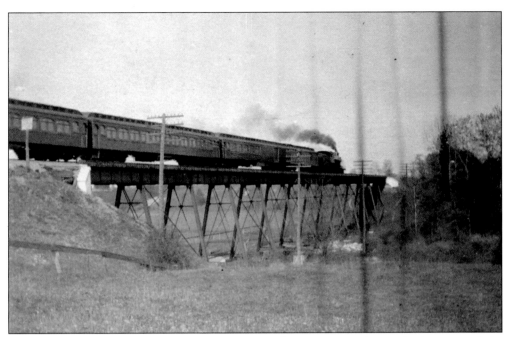

PERE MARQUETTE TRESTLE. A Pere Marquette train crosses over the trestle that spanned the Rouge River in Plymouth.

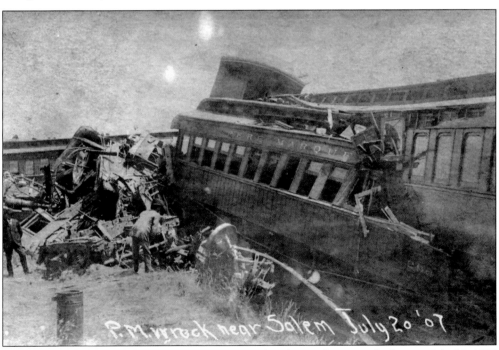

TRAGEDY. One of the largest disasters to occur in the Plymouth area took place on July 20, 1907 near Salem, Michigan (about four miles west of town). An eastbound Pere Marquette train, filled with passengers from Ionia, Michigan collided head-on with a six-car freight train resulting in 33 deaths and 100 injuries.

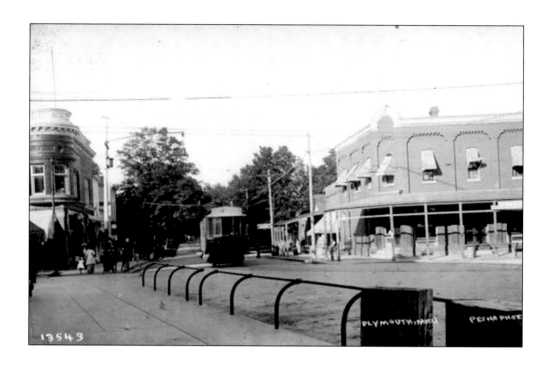

INTERURBAN. The Detroit, Plymouth & Northville Railroad (or the "Interurban") ran between 1898 and 1924. It allowed for greater passenger service between Plymouth and Northville and Plymouth and Wayne. Above, the Interurban train is stopped outside the station on Main Street, and below, it passes through the Phoenix Tunnel between Northville and Plymouth. A Pere Marquette train crosses over the Phoenix Tunnel.

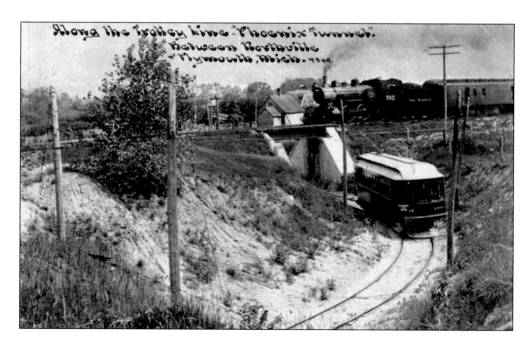

Two

BUSINESSES

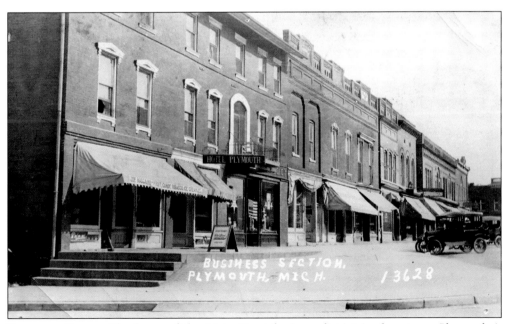

PHOENIX BLOCK. The heart of the Main Street business district in downtown Plymouth is housed in the Phoenix Block—appropriately named because the business district has risen from the ashes after fires in 1856 and 1893.

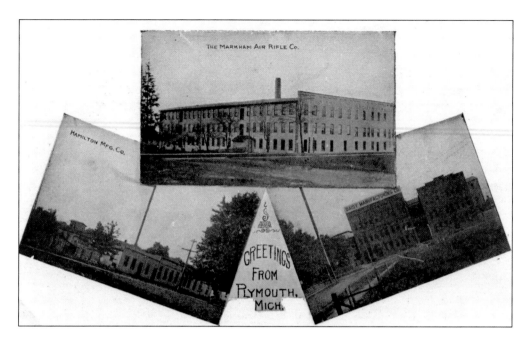

RIFLES GALORE. In the 1890s, Plymouth was home to four rifle manufacturers: Plymouth Air Rifle Company, Markham Air Rifle Company, Daisy Manufacturing Company, and Hamilton Manufacturing Company. Plymouth Air Rifle mysteriously burned and ceased operations in 1894. (Below) In 1912, executives of the Daisy Manufacturing Company purchased nearly all of the Markham Air Rifle Company. Markham continued to manufacture King Air Rifles and later changed the name to King Manufacturing Company.

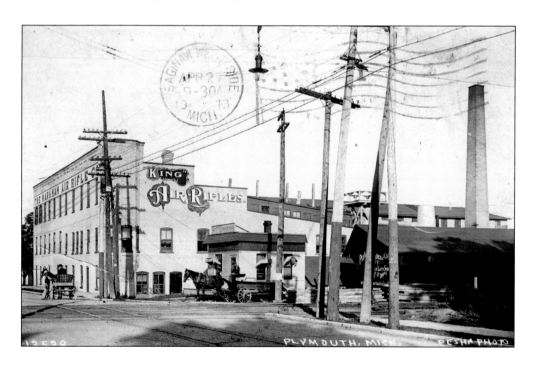

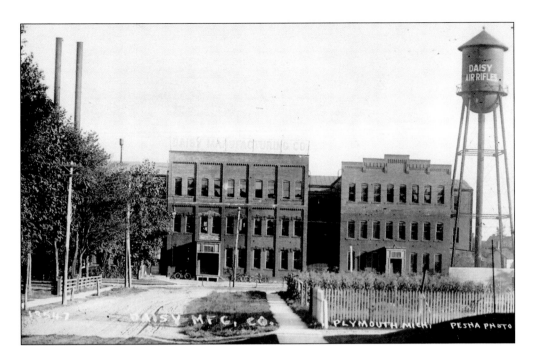

DAISY MANUFACTURING COMPANY. Daisy put Plymouth on the global map with the sale of its Daisy Air Rifle to children around the world. Daisy began its manufacturing life as the Plymouth Windmill Company, but shifted gears when the air rifle became more popular than the windmill. The company called Plymouth home from the late 1880s until 1958, when it moved to Rogers, Arkansas. These buildings still stand but may be renovated or demolished for condos.

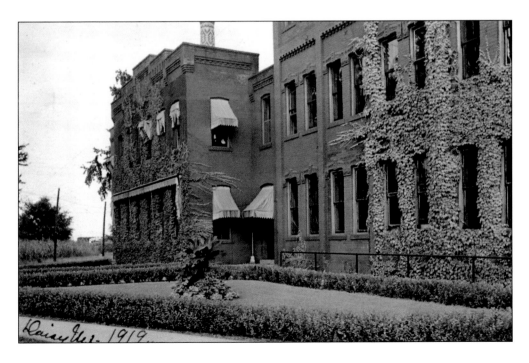

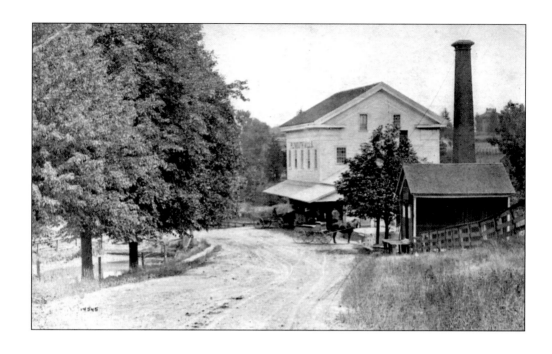

PLYMOUTH AND WILCOX MILLS. Plymouth Mills (above) was built by Henry Holbrook in 1845 and became Wilcox Mills in 1879 when the Wilcox brothers bought it. It was in continuous operation until Henry Ford tore it down and built the small Plymouth plant of Ford Motor Company (below). The building is now owned by the Wayne County Parks. (Bottom postcard from the collection of Joe LaBeau.)

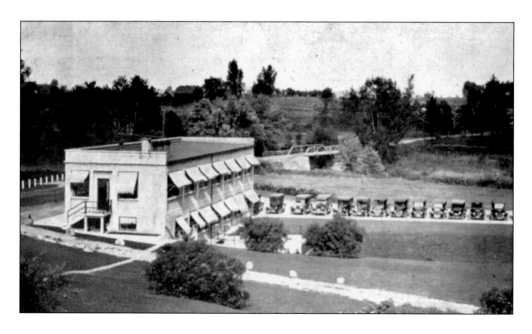

PHOENIX MILL AND PLANT. The Phoenix Mill, on the opposite side of the Phoenix Bridge, was on the site of the extinct village of Phoenix. A mill was located at this site from 1840 until the gristmill burned down in 1905. Henry Ford bought and rebuilt the dam below the bridge after it broke in 1920.

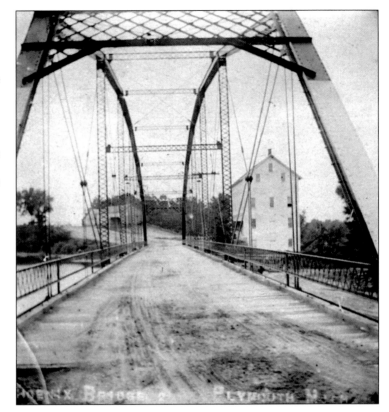

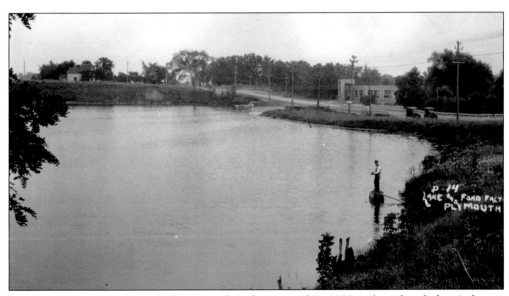

PHOENIX PLANT. Ford also built a new plant that opened in 1922 and produced electrical parts, voltage regulators, and switches. The Phoenix Plant employed only single or widowed women between the 1920s and 1940s. The plant is slated to become a women's museum in the near future.

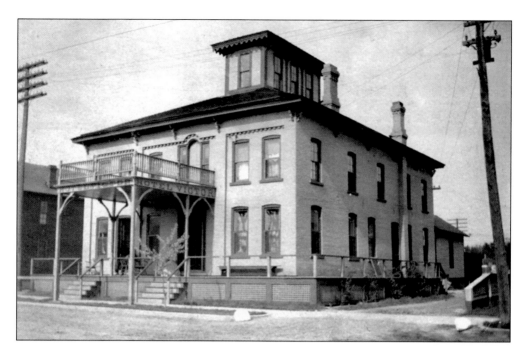

HOTEL VICTOR AND HOTEL ANDERINE. The Hotel Victor opened during the 1880s on North Mill Street (above). It primarily served railroad passengers and workers for much of its history. The hotel was later remodeled, and sometime between 1925 and 1927, it was renamed the Hotel Anderine (below). The Sambrone family ran the hotel for about 60 years. It changed hands several times and was also known as the Nelson Hotel and the Old Village Inn. The building burned down in the 1980s.

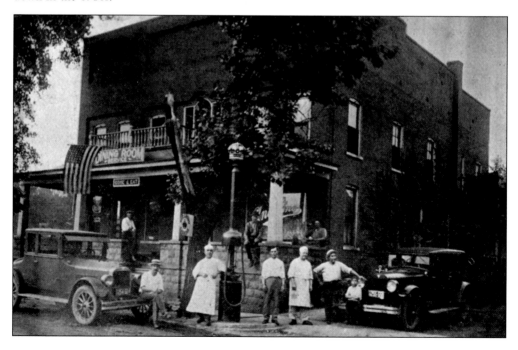

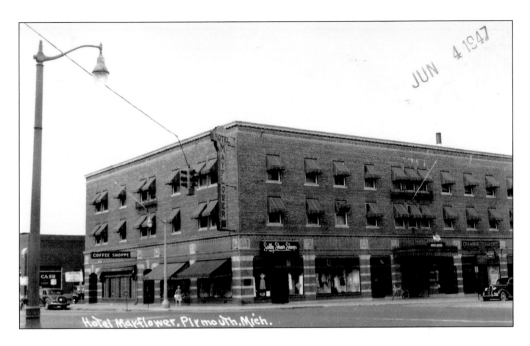

MAYFLOWER HOTEL. The Mayflower Hotel was a vision of the notable businessmen in Plymouth in the mid-1920s. They recognized that there was no hotel between Detroit and Ann Arbor at the time, and set about raising the capital to build one. It was a community project that set a record for fund-raising—in about five hours the group had raised $250,000. The hotel was a mainstay in downtown Plymouth from its opening in November 1927 until it went into bankruptcy and was torn down in 1999. In its place stands a three-story business and residential structure called the Mayflower Center. (Top postcard from the collection of Mike Pappas.)

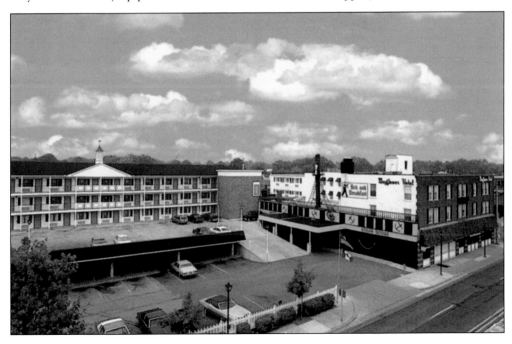

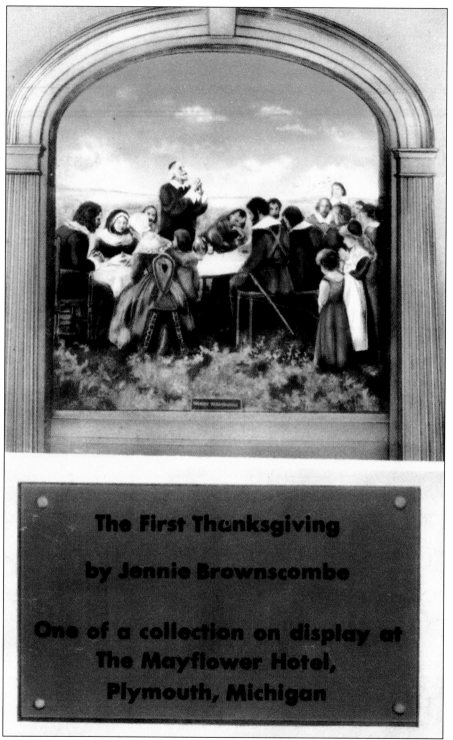

THE FIRST THANKSGIVING. This painting (and several others) hung on the dining room walls in the Mayflower Hotel. The original paintings came from Plymouth Hall in Plymouth, Massachusetts.

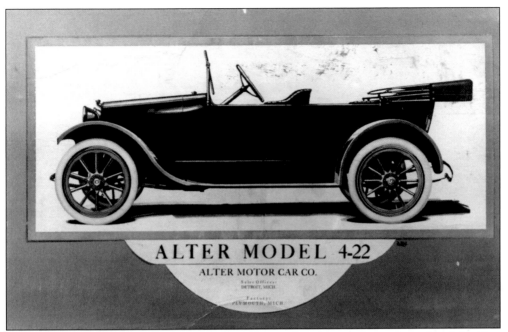

ALTER MODEL 4-22

ALTER MOTOR CAR CO.

DETROIT, MICH.

PLYMOUTH, MICH.

ALTER CAR. From 1914 to 1916, the Alter Motor Car Company in Plymouth produced the Alter car from a design by Clarence Alter of Manitowoc, Wisconsin. The car was made of component parts shipped to Plymouth by rail and then assembled at the factory that still stands on Farmer Street. The company couldn't keep up with demands or get further financing and went into receivership. The only known Alter Car is on display in the Plymouth Historical Museum.

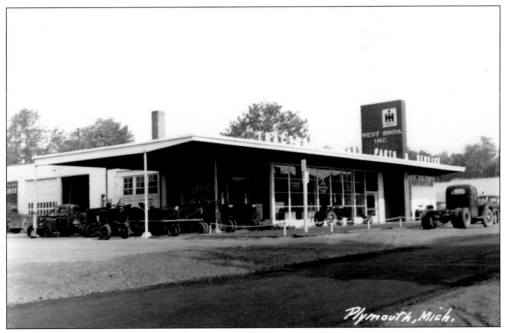

TRACTORS. West Brothers Inc. sold and serviced tractors and trailers in Plymouth.

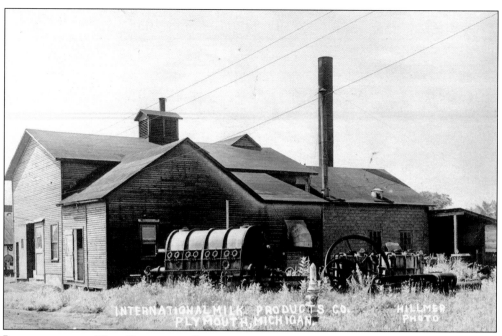

INTERNATIONAL MILK PRODUCTS COMPANY.

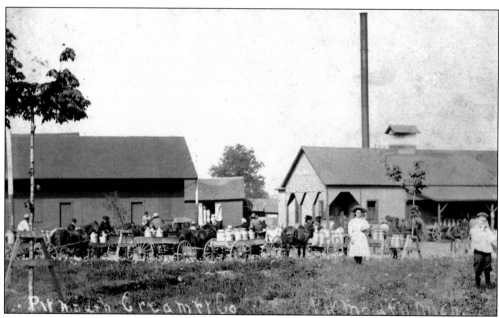

PLYMOUTH CREAMERY COMPANY. A local cooperative group organized the company in 1901. Farmers came from miles around to empty their milk cans and to exchange pleasantries with creamery superintendent Mathew Powell. About 1912, the plant became a receiving station for the Detroit Creamery Company, makers of "Velvet" ice cream.

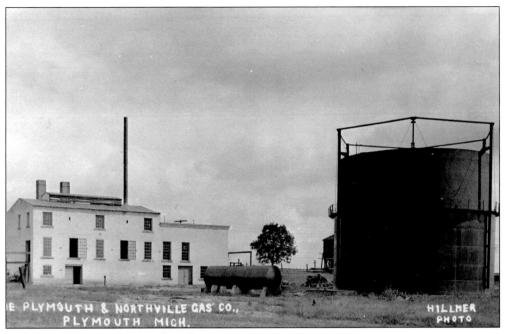

PLYMOUTH & NORTHVILLE GAS COMPANY.

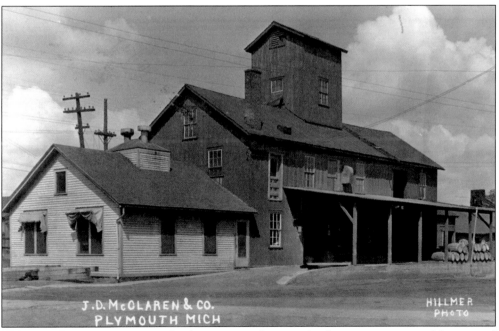

J.D. McLaren & Company. This business was first a grain elevator company and later a coal and lumber business located on Main Street just north of the railroad tracks. McLaren purchased a string of grain elevators from L.C. Hough in 1901. The company closed in 1975 after the death of John J. McLaren, J.D.'s son, who took over the business in 1915 when his father died.

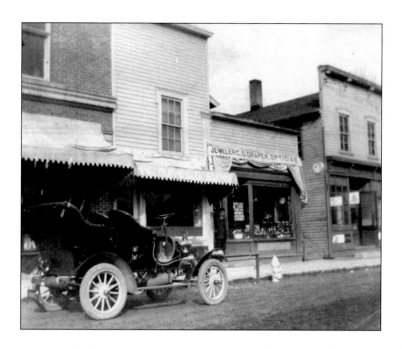

W.O. ALLEN AND C.G. DRAPER. In the above postcard, Allen's and Draper's storefronts are pictured on Main Street. Charlie Berdan's car is parked in front of Allen's store, as he took care of business for Kate Allen, wife of W.O. Below, the interior of C.G. Draper's Jewelry Store (exterior shown center, above) on Main Street is pictured as it appeared *c.* 1905.

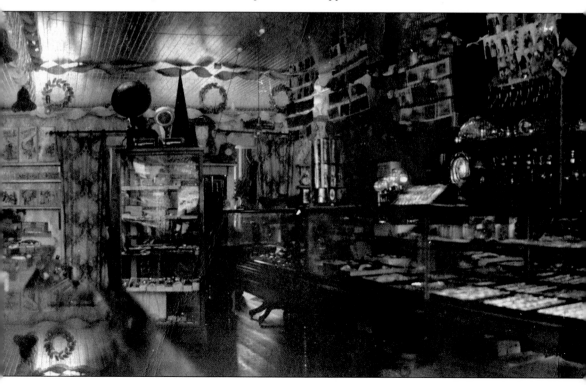

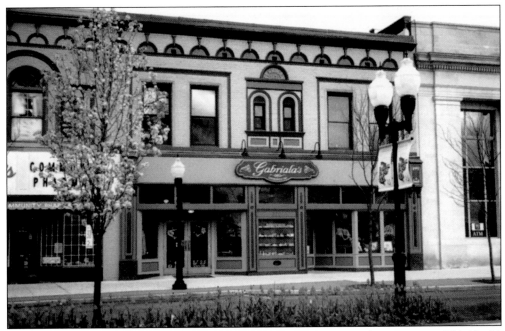

GABRIELA'S. Gabriela's stands today where clothing and drug stores stood a century ago. This block's buildings have burned to the ground twice in the history of Plymouth, once in 1856 and again in 1893. The building that houses Gabriela's and Wiltse Pharmacy (at left) was built after the fire of 1893. (Used with permission of Gabriela's owner, Larry Bird; from the collection of the author.)

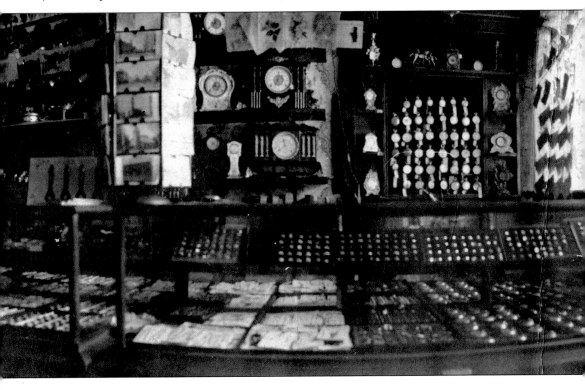

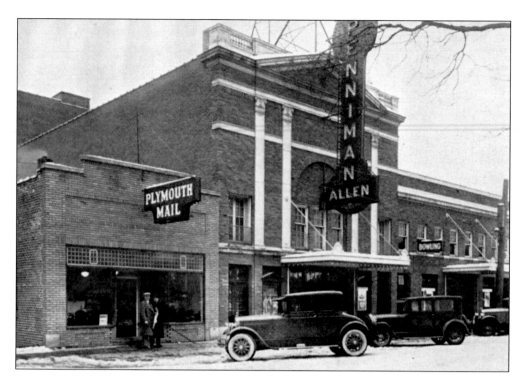

THEATERS. Kate Penniman Allen built the Penniman-Allen Theater (above) on Penniman Avenue in 1918. Controversy arose in 1922 when Allen announced the theater would show movies on Sundays in addition to weekdays. The building burned down in 1968 and a parking lot now stands in its place. The *Plymouth Mail* began publishing in 1887 and continued to serve the Plymouth community for 80 years until it became part of the Observer group. Harry Lush built the Penn Theater (below) in 1941, on Penniman Avenue across from Kellogg Park. The theater is still in use today and recently returned to showing first-run movies.

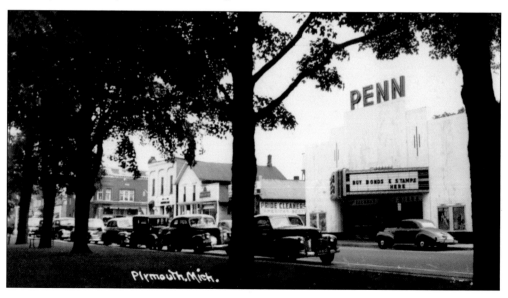

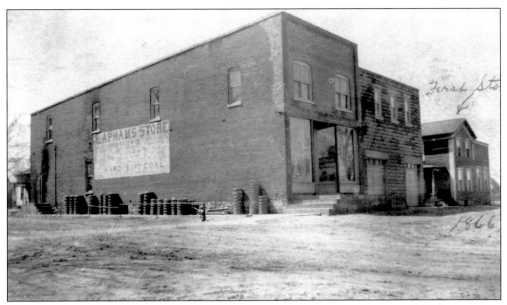

LAPHAM'S STORE. Andrew Jackson Lapham built his first store in Plymouth's Old Village in 1866 and later opened a coal and cement business two doors away.

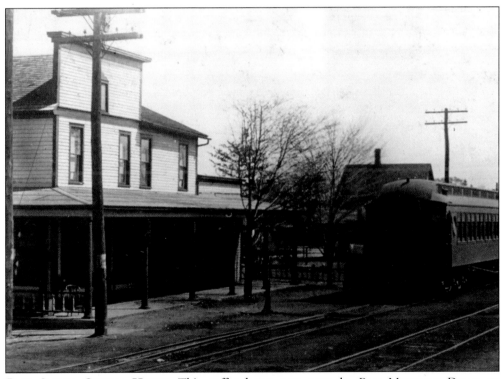

DAN SMITH COFFEE HOUSE. This coffee house was near the Pere Marquette Depot on Starkweather Road. In 1908, the building sustained considerable damage when a caboose from a Pere Marquette train jumped the tracks.

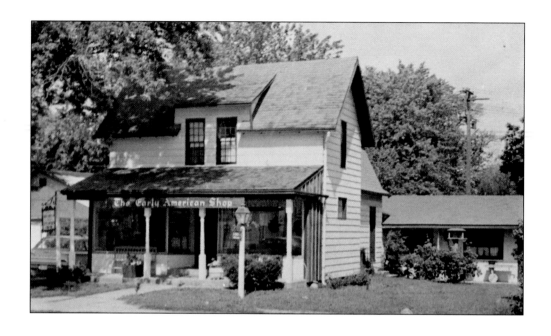

SHOPS. The Early American Shop (above) spent several decades at 621 S. Main Street beginning in the mid-1950s. Journey Bodywork and Spa now occupies the building. Heide's Flowers (below) has been in business in Plymouth for more than a century. It was at the corner of S. Harvey Street and Ann Arbor Trail until it moved to Main Street in 2003. (Bottom postcard used with permission of owner Steve Mansfield.)

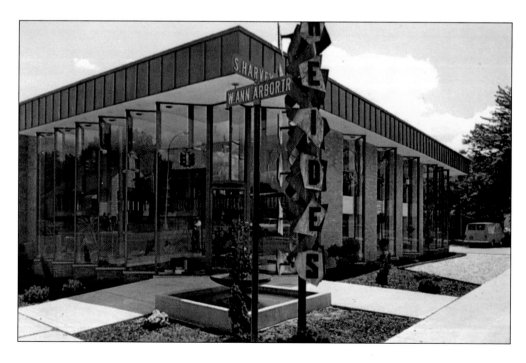

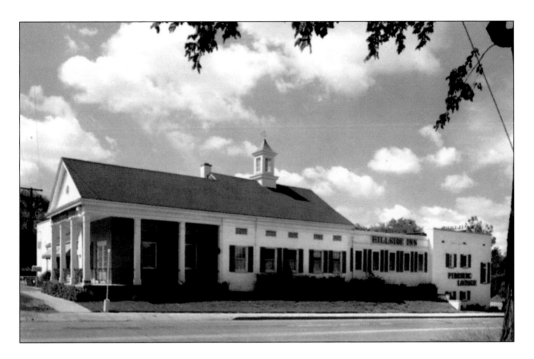

RESTAURANTS. Jacob Stremich and his wife Margaret Streng opened Hillside Inn (above) in 1934 in Margaret's family homestead on Plymouth Road. Initially it was called Hillside Barbecue but was later renamed. The building was expanded over the years to include the pictured Fireside Lounge. The Hillside Inn became Ernesto's, an Italian Country Inn, in the late 1980s. The Bodes Inn, which later became Bodes Restaurant (below), has been just south of the tracks on Main Street for more than a century. (Bottom postcard used with permission of artist Gordon Eddy; from the collection of Charles Montgomery.)

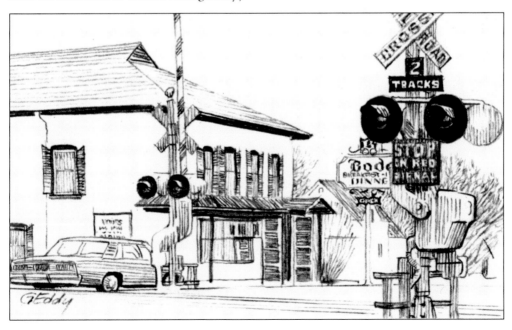

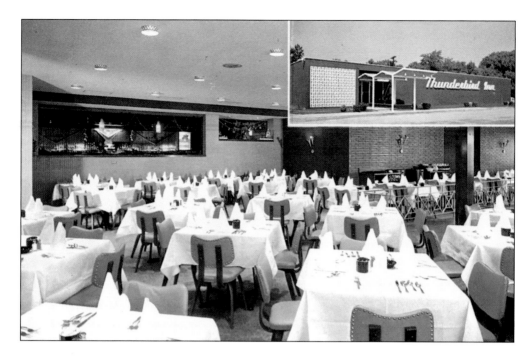

FORMER BUSINESSES ON THE SAME GROUND. The Thunderbird Inn (above) was located on Northville Road until it burned down. Soon afterwards, the Plymouth Hilton (below) was built on the property, with the hopes that an interchange would be built near it off the new route M-14. The new interchange was never constructed and the Hilton closed its doors. The building now houses Independence Village, a retirement community.

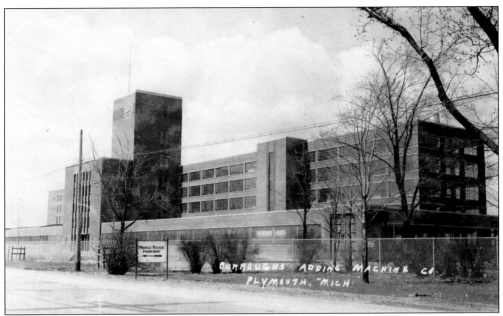

BURROUGHS ADDING MACHINE COMPANY. The Burroughs plant was built in 1938 on Plymouth Road. The company built business machines and sent them around the world. In 1986, Burroughs merged with Sperry Corporation to form Unisys Corporation, headquartered in Blue Bell, Pennsylvania. The company now produces computers and still occupies the building.

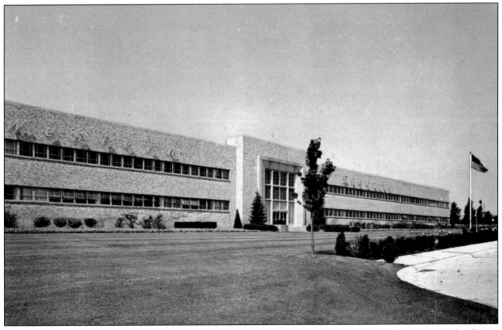

WESTERN ELECTRIC COMPANY. The distributing house for Western Electric was built on Sheldon Road in Plymouth in 1958. The structure is 420,000 square feet. Today the building houses several businesses and looks only slightly different.

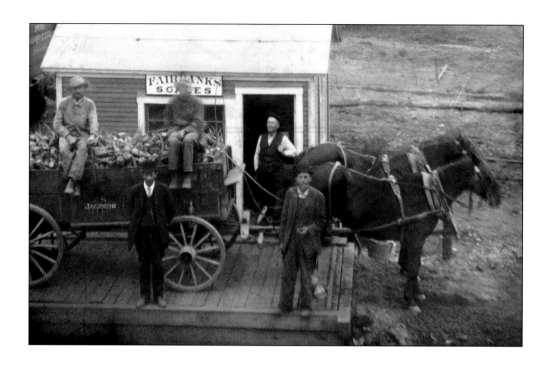

SUGAR BEETS. Sewell Bennett (in doorway, above) and Paul Bennett (on right) weigh sugar beets before the load is taken to the rail yard for shipment to Saginaw, Michigan (below). Paul Bennett holds the flag.

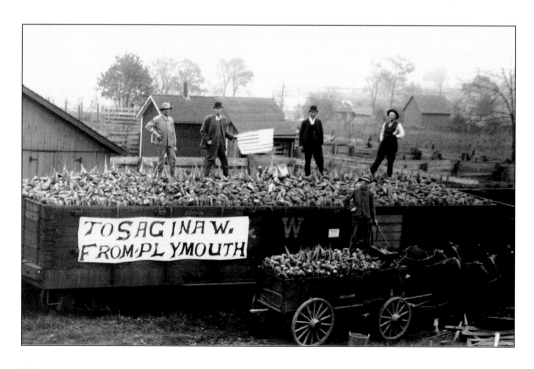

Three

BUILDINGS

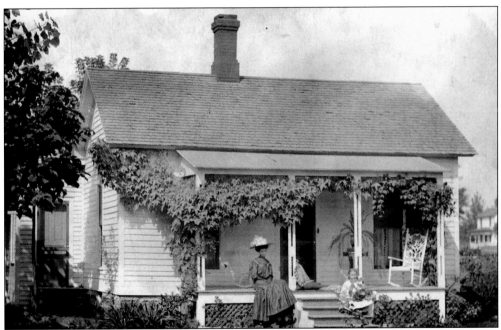

HOME SWEET HOME. Hazel Huffman sits on the porch of her home at 230 S. Main Street in the early 1900s. The home is no longer standing.

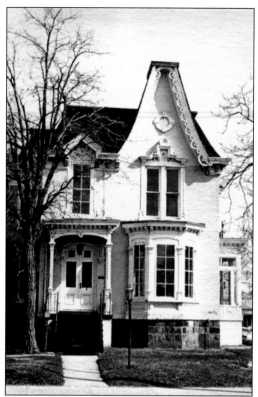

THE BAKER HOUSE. The Baker House (left) at 233 S. Main Street was known as "The Pink Lady" at the time this postcard was printed, because the high Victorian Gothic style house was painted pink in 1980. It housed a beauty salon at the time. The home was built by Henry Baker in 1875 and remained in the hands of the original owners until 1943. Henry Baker was the Chairman of the Board and President of Daisy Manufacturing Company. The house is now used as a commercial building.

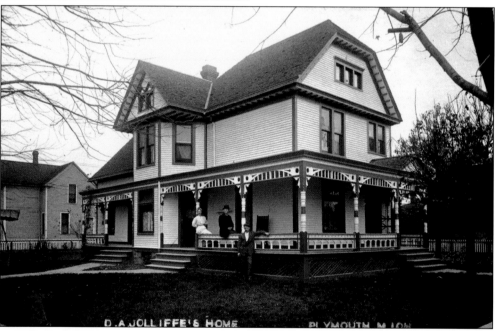

JOLLIFFE HOUSE. The Daniel A. Jolliffe House at 725 Mill Street was built in 1894 in the popular Victorian style. The house was sold to the Beyer family in the early 1900s. The home is still standing and is privately owned.

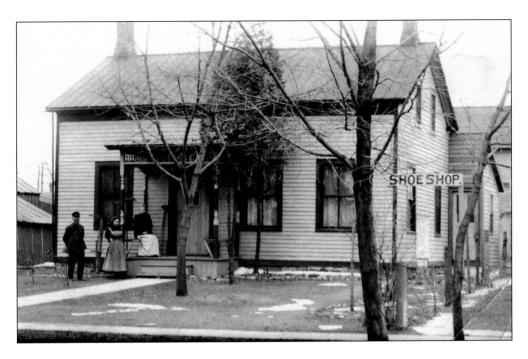

HOMES. The home pictured above possibly belonged to the Gayde family and the photo was taken in approximately 1916. The home seen below still stands at 854 Church Street. (Below postcard from the collection of the author.)

PENNIMAN HOUSE. Mrs. Kate Penniman Allen's residence at 1160 Penniman Avenue was a Greek Revival house built in 1840 by her father, Ebenezer Jenckes Penniman. Today it serves as the rectory for Our Lady of Good Counsel Catholic Church.

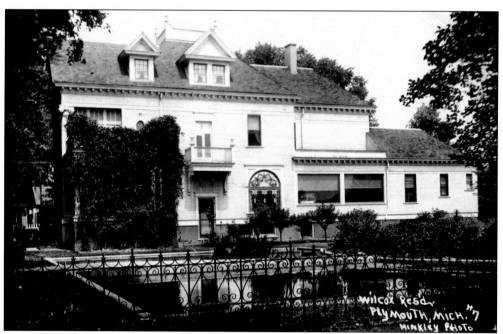

THE WILCOX HOUSE. This house was originally built for William F. "Philip" Markham, owner of Markham Air Rifle Company. He sold the house in 1911 to George Henry Wilcox. The house stayed in the Wilcox family until George's son Jack died in 2000. The surrounding property is now being developed by a commercial contractor.

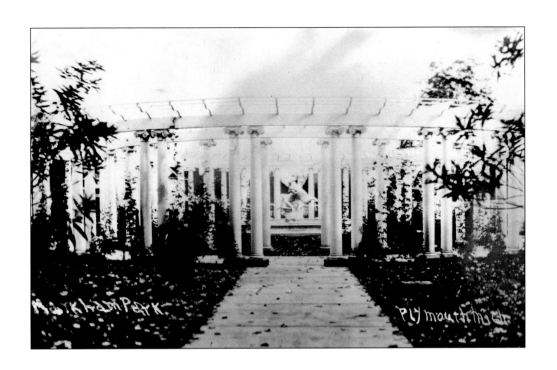

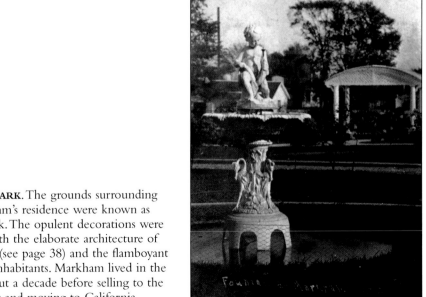

MARKHAM PARK. The grounds surrounding Philip Markham's residence were known as Markham Park. The opulent decorations were in keeping with the elaborate architecture of the residence (see page 38) and the flamboyant nature of its inhabitants. Markham lived in the house for about a decade before selling to the Wilcox family and moving to California.

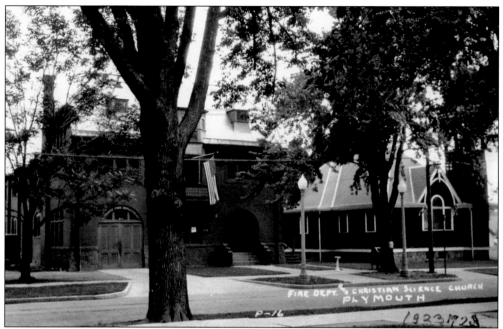

PLYMOUTH VILLAGE HALL, FIRE DEPARTMENT AND CHRISTIAN SCIENCE CHURCH. The Village Hall opened in 1890 on S. Main Street just north of downtown. In addition to the Fire Department, the Village Hall also housed the Plymouth Opera House, where civic and cultural events were held.

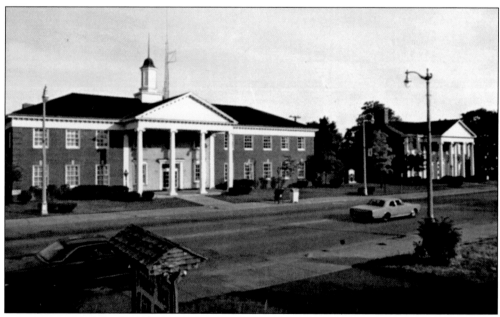

NEW PLYMOUTH CITY HALL. The old Village Hall served the community well for nearly three-quarters of a century, but the city found it needed to modernize and consolidate offices. The new City Hall opened in November 1964 on the property formerly occupied by the Christian Science Church. The Church moved to its current location on Ann Arbor Trail.

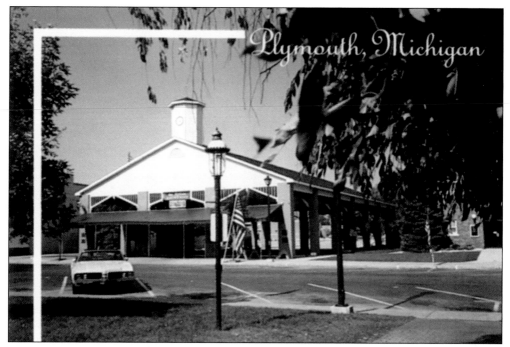

THE GATHERING. The Plymouth Gathering is, as its name implies, a place for citizens to gather for the Farmers' Market in the summer and various festivals throughout the year. The property was originally residential, but the City of Plymouth built the structure in 1982 for the use of the community. It faces Kellogg Park on Penniman Avenue.

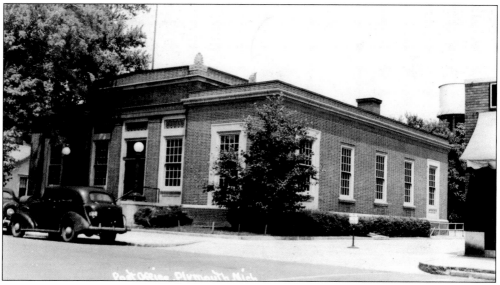

UNITED STATES POST OFFICE. The Penniman Avenue Post Office was built in 1936 and remodeled in 1958, but still looks virtually the same. When the U.S. Postal Service built a new, larger facility in Plymouth Township, it tried to close the Penniman Avenue office. There was such an outcry from the local citizens, however, that the branch remains open today and is within the heart of downtown Plymouth. (From the collection of Mike Pappas.)

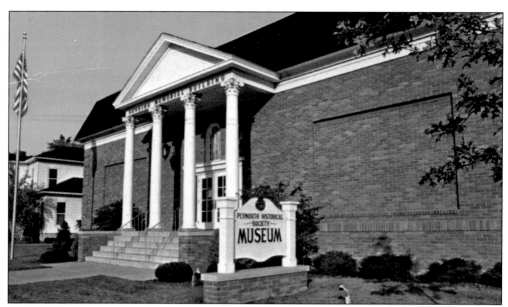

PLYMOUTH HISTORICAL SOCIETY MUSEUM. The museum, in the Dunning Memorial Building, sits on the former site of Anson Polley's blacksmith shop. The museum started out in Polley's house but when larger facilities were needed, this building was erected. More space was needed again to house the recently purchased Lincoln collection, so in 2001 an additional 9,800 feet were added to the existing 16,000-square-foot building.

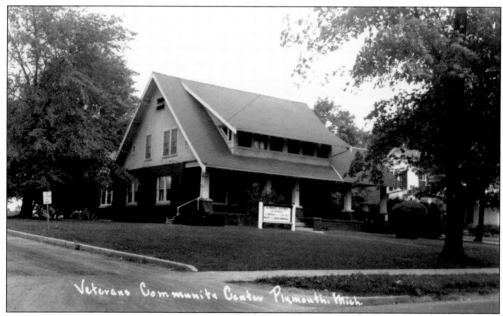

THE VETERANS' COMMUNITY CENTER. The Veterans' Community Center was dedicated November 9, 1947. Mrs. Mariette Hough donated the home, at 173 N. Main Street, to be used as a meeting place for Plymouth veterans.

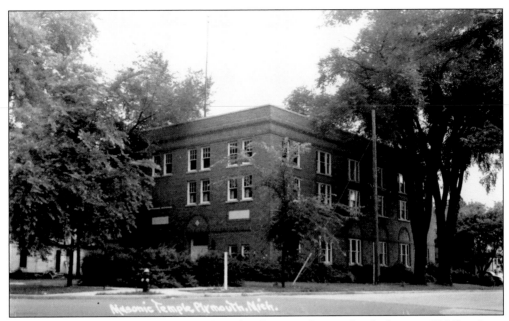

MASONIC TEMPLE. The Plymouth Rock Lodge #47, F. & A.M. makes its home at 730 Penniman Avenue in its Masonic Temple, which was dedicated in December 1924. The Lodge has existed in Plymouth in varying states of membership since 1851, and it still uses this building, which is adjacent to the Plymouth Gathering.

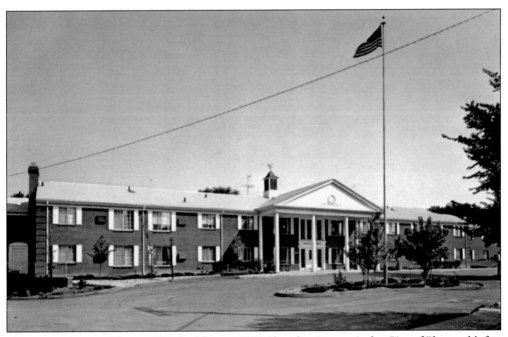

TONQUISH CREEK MANOR. This building, at 1160 Sheridan Avenue, is the City of Plymouth's first housing project for the elderly. It was dedicated May 16, 1970 and sits adjacent to Tonquish Creek.

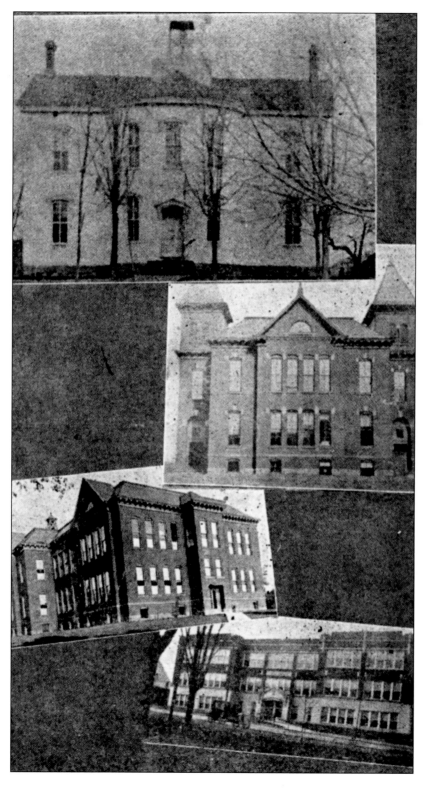

PLYMOUTH HIGH SCHOOLS. E.J. Penniman built the first public school in the Village of Plymouth on Church Street in 1840 (top). In 1884, the building was purchased by Marvin Berdan and moved elsewhere. That same year, construction began on a brick school building (second from top). In 1907, the school building was remodeled and the towers were removed (second from bottom). This building was used until it burned to the ground in March 1916. The high school was rebuilt on the same location and is used today as Central Middle School (bottom).

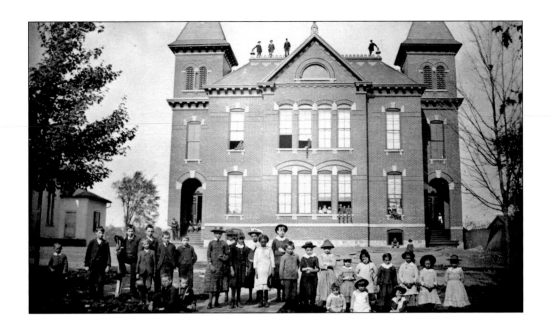

PLYMOUTH HIGH SCHOOL BUILDINGS. These are probably the most photographed buildings in Plymouth over the past century or so. The second Plymouth High School building (above) was actually used for both grade school and high school children. Note the people posing on the roof of the building. The remodeled Plymouth High School building (below) was a stately structure with ivy-covered walls.

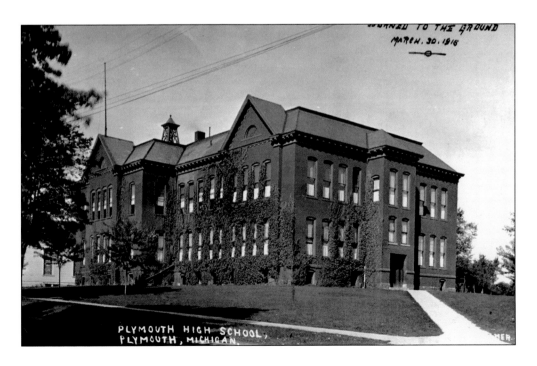

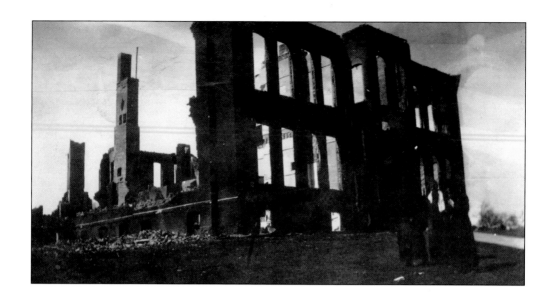

FIRE. The Plymouth High School fire of March 31, 1916 is believed to have started in the furnace room. The Methodist Episcopal Church adjacent to the high school also burned in the fire.

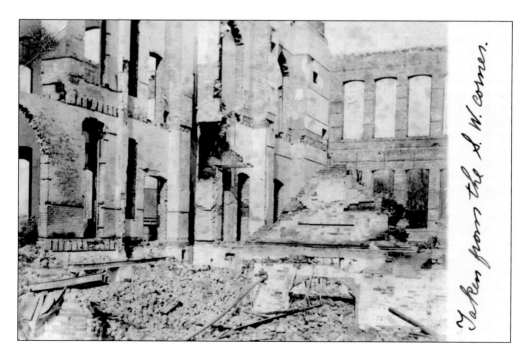

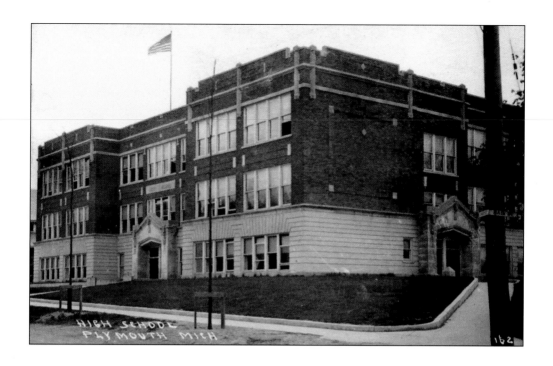

PLYMOUTH HIGH SCHOOL. The high school was rebuilt after the fire, but students of all grades were displaced until the new school was built. The original building was remodeled, with the addition of a gymnasium. This building is now used as Central Middle School. High school students now attend classes in Canton in a consolidated educational park with three high schools for the use of Plymouth, Canton, and Salem students.

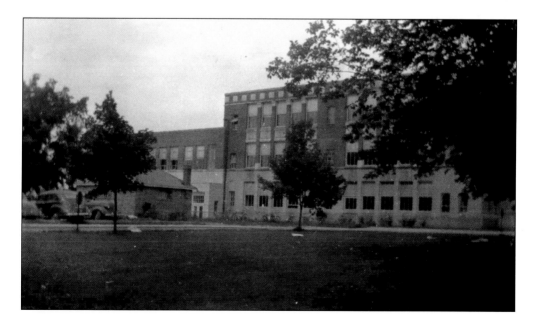

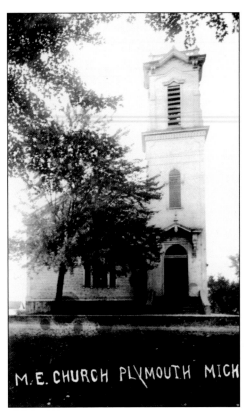

M. E. CHURCH PLYMOUTH MICH

METHODIST EPISCOPAL CHURCH. The Methodist Episcopal Church was built in 1848 and remodeled in 1874 and 1914, just prior to burning down along with the Plymouth High School in March 1916. The church, located on Church Street, was rebuilt after the fire (below). The Methodist congregation worshiped in this building until March 1972, when their new building on North Territorial Road in Plymouth Township was consecrated. The old building is now used by Solid Rock Bible Church.

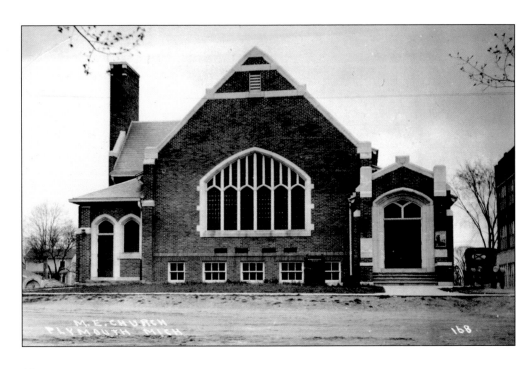

M. E. CHURCH PLYMOUTH MICH 168

FIRST PRESBYTERIAN CHURCH. The Presbyterian congregation began meeting in private homes in 1835 in Plymouth. The first church building was brick and was used until another church was built in 1849. The first church building was then sold to the Baptists. The Presbyterian Church is located at the curve on Church Street just before it intersects Main Street. The church grounds were originally used as the village cemetery. Over the years, the church has suffered fire damage and has been renovated several times—most recently in 2002 when the building received an addition.

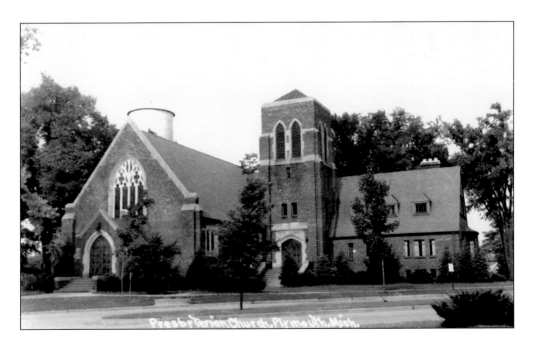

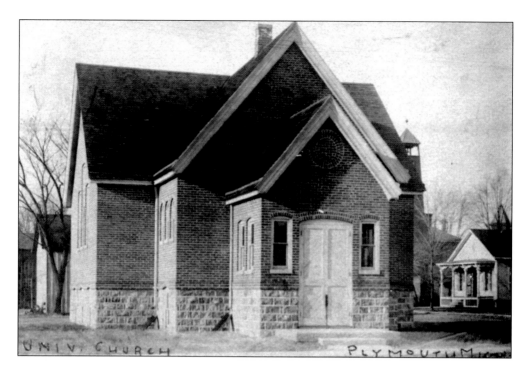

TWO CHURCHES, ONE BUILDING. The Universalist Church (above) was built in 1900 on the corner of Union and Dodge Streets. The building was abandoned, and around 1920 the growing Catholic Congregation of Our Lady of Good Counsel purchased it (below). The Catholics met here until it was destroyed by fire on 23 December 1932. The congregation later built a new church on the corner of Penniman Avenue and Arthur Street next to E.J. Penniman's house.

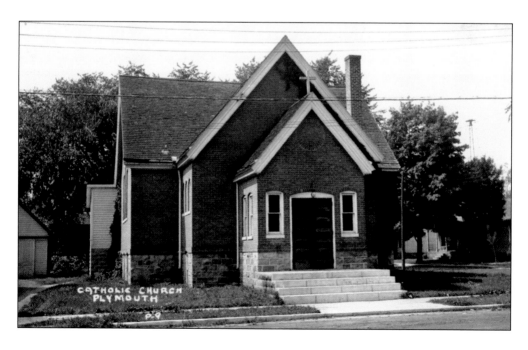

ST. PETER'S EVANGELICAL LUTHERAN CHURCH. St. Peter's was built in 1883, replacing an earlier building acquired from the Baptists. The current church building (not pictured), on the corner of Penniman and Evergreen, was dedicated in 1955.

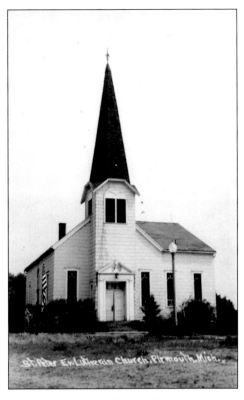

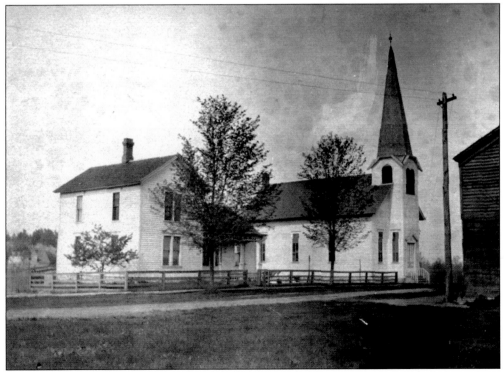

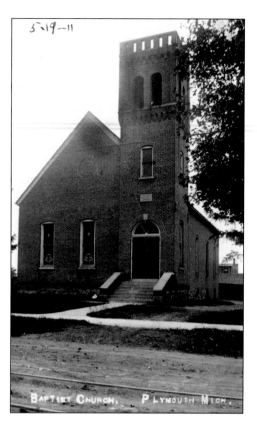

BAPTIST AND CHRISTIAN SCIENCE CHURCHES. The First Baptist Church (left) was built in 1856 on North Mill Street. The building was later remodeled and then sold in 1968. The congregation then moved to a newer structure on North Territorial Road near Ridgewood. This building is now used by St. Michael's Catholic Church. The Christian Science Church (below) on the corner of Main and Dodge Streets was dedicated in 1903. In the 1960s, the church property was sold to the City of Plymouth for its new City Hall, built adjacent to the older hall. The Christian Science congregation built a new facility on Ann Arbor Trail. (Both postcards from the collection of Mike Pappas.)

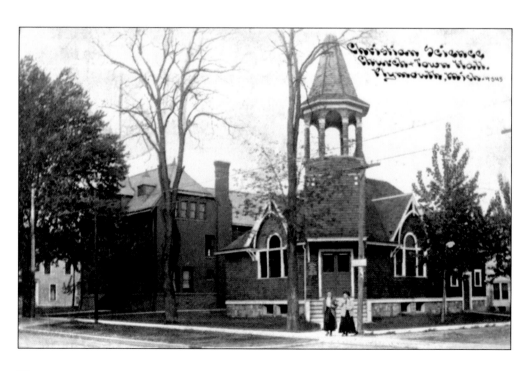

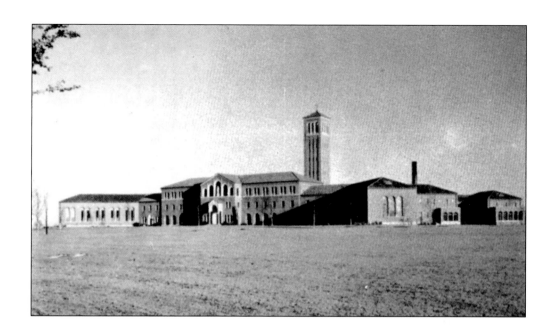

ST. JOHN'S PROVINCIAL SEMINARY. St. John's Provincial Seminary was founded in 1948 by Cardinal Mooney. At one time the seminary housed every man studying for the Catholic priesthood in Michigan, both undergraduate and graduate. At its peak the seminary housed 250 students, but the enrollment dwindled and the seminary closed in the 1980s. Today the seminary has new life as the St. John's Golf and Conference Center. The center is on the corner of Sheldon and Five Mile roads in Plymouth Township. The room below was used to serve the resident students three meals a day. (Postcards courtesy of the Archdiocese of Detroit.)

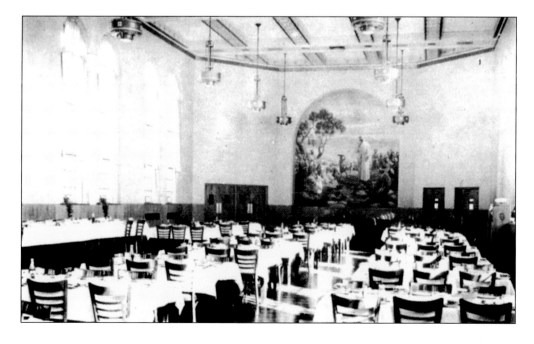

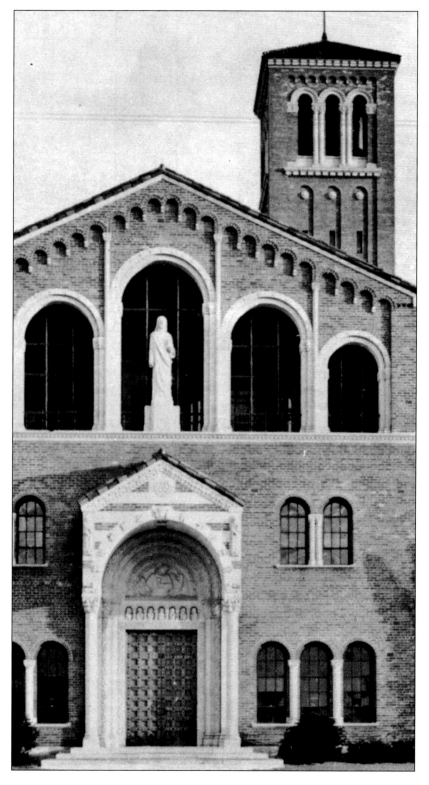

ST. JOHN'S PROVINCIAL SEMINARY. Cardinal Mooney based the design for the seminary on one he saw while traveling in Italy. (Postcard used with permission of of the Archdiocese of Detroit.)

Four

STREETS

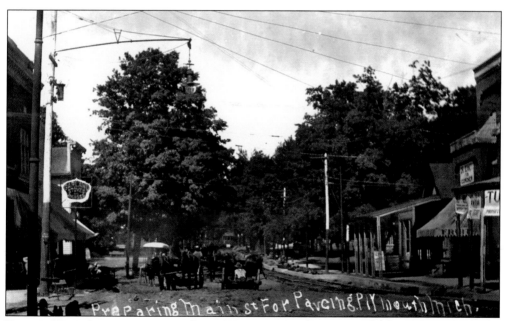

PAVING MAIN STREET. In 1908, Plymouth's citizens approved the paving of Main Street with brick. The Common Council of the village had declared it necessary because, as they put it, "Plymouth has absolutely the worst Main Street of any village in the State of Michigan."

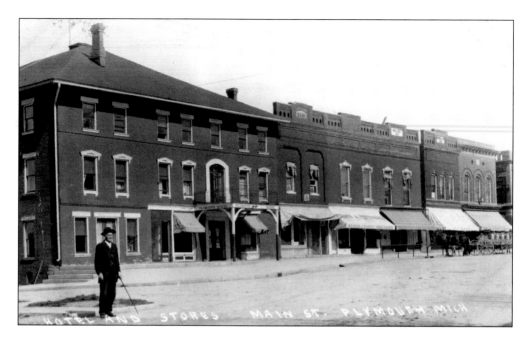

MAIN STREET LOOKING NORTH. The buildings in the Phoenix block on South Main Street were built after the fire of 1893. The Plymouth Hotel, above, on the left with no awnings, was a stop on the stagecoach line. Note the milk delivery cart on the right. Harry Robinson's horse-drawn "bus" (below, center) carried passengers from the hotel to the railroad station. This postcard dates before 1908 when the roads were paved with brick. Note that the hotel now has canvas awnings. On the far right of the below postcard, the Detroit Urban Railroad—or Interurban—is stopped in front of its station. (Bottom postcard from the collection of Mike Pappas.)

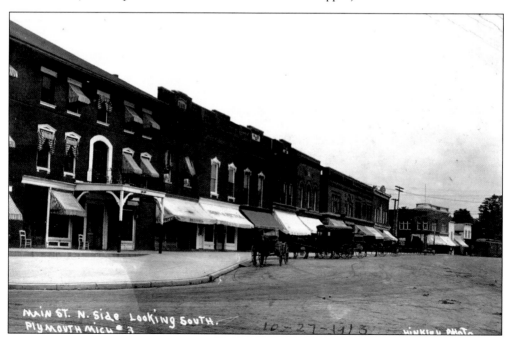

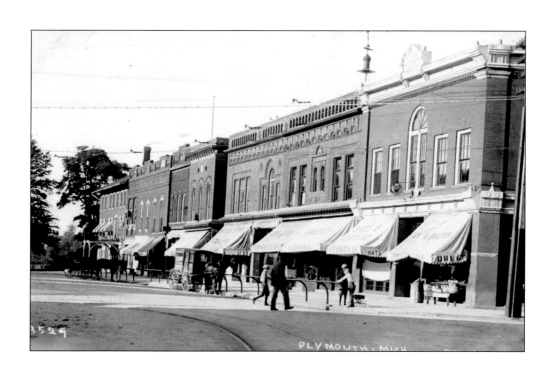

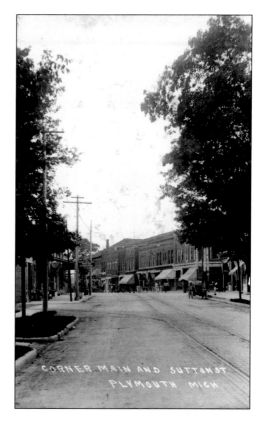

MAIN STREET LOOKING SOUTH. Canvas awnings line the shops on the Phoenix block (above). The tracks in the foreground are for the Interurban. This postcard is from about 1913. Automobiles started making their appearance in the early 1900s in Plymouth (right). For many years, though, there was a mix of autos and horse-drawn carriages on the roads. Brick can be seen clearly on the street, and because Sutton Street is mentioned, the postcard can be dated between 1908 and 1912, when Sutton was renamed Penniman Avenue. A sign for the Interurban station is on the left.

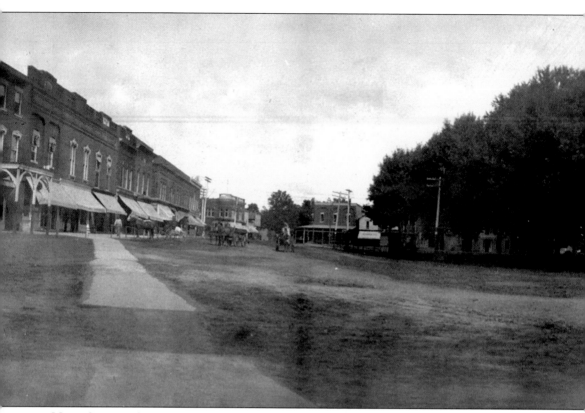

MAIN STREET, ANN ARBOR STREET, AND CENTRAL PARK. This panoramic postcard gives a view from the intersection of South Main Street and Ann Arbor Street (now Ann Arbor Trail). This image was taken before 1908, when the roads were paved, but note the plank sidewalks on

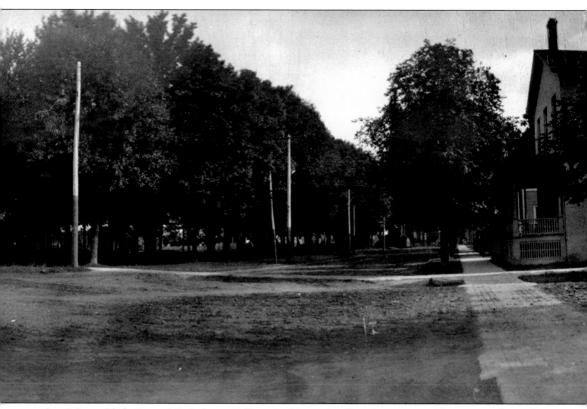

the right and left. Central Park (now Kellogg Park) stands tall in the center of the image. The park was given to the people of Plymouth by early landowner John Kellogg.

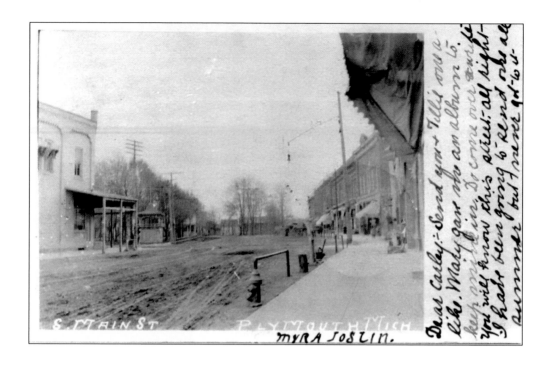

S. MAIN ST PLYMOUTH MICH.

MYRA JOSLIN.

MAIN STREET LOOKING SOUTH. Main Street in Plymouth is well-documented in photos and postcards, ranging in dates from the 1860s to the present. The above postcard clearly shows the terrible state of the dirt roads prior to paving. Hitching posts line the street and the park's bandstand is visible beyond the building on the left. In the postcard below, the streets are paved with brick and some of the hitching posts have been removed.

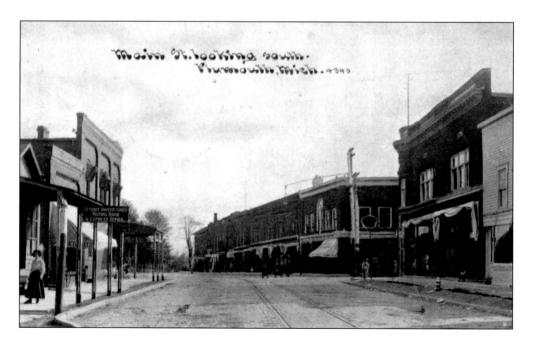

Main St. looking south.
Plymouth, Mich. 4345

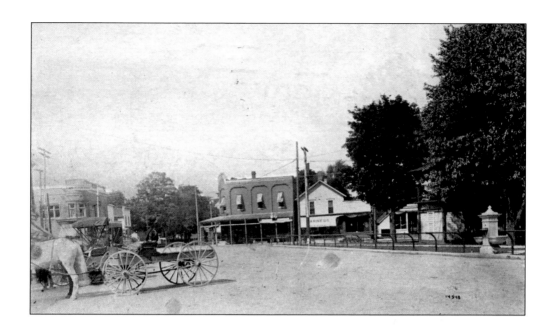

MAIN STREET VIEWS. Looking north on Main Street, the image above shows Central/Kellogg Park visible on the left, with hitching posts and bandstand. Conner Hardware is the building on the left at the corner of Main and Sutton Street/Penniman Avenue. That building is still standing. The Phoenix Block of Main Street is pictured below, as seen from within Central/Kellogg Park. At that time, the trees in the park were denser than they are today.

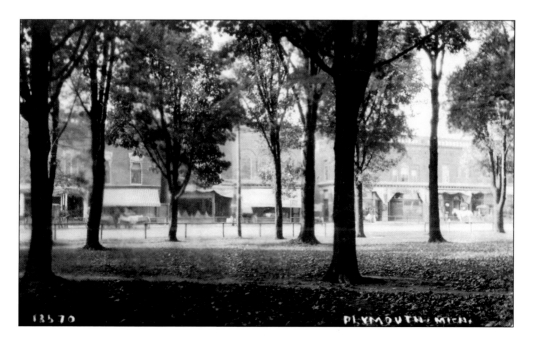

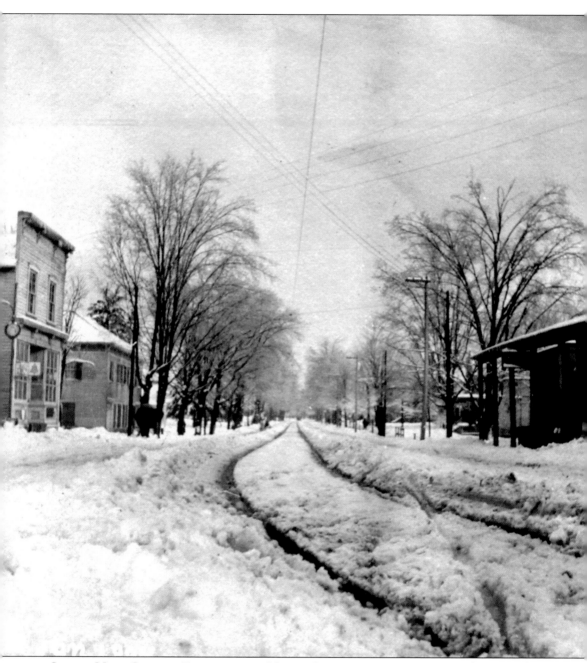

SOUTH MAIN STREET, FOLLOWING A MAJOR STORM IN JANUARY 1904. The Interurban trains were able to get through using plows on the front end of the cars. The image was shot from the corner of Main and Sutton streets.

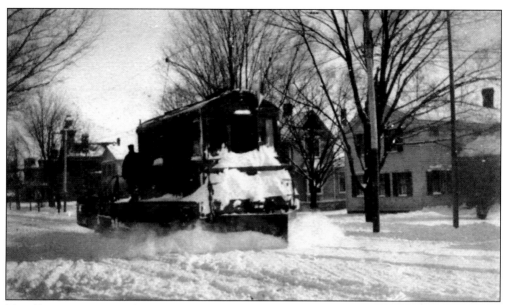

THE INTERURBAN, IN SERVICE REGARDLESS OF THE WEATHER. With a plow on the front, the Interurban cars could easily make their way along the tracks.

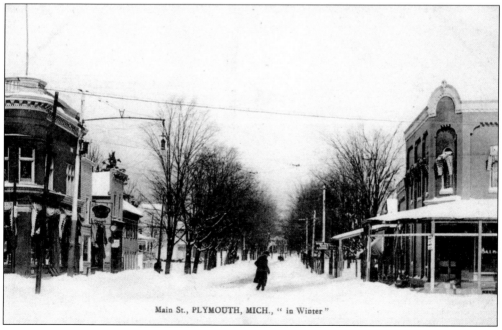

Main St., PLYMOUTH, MICH., " in Winter "

MICHIGAN WINTERS. Winters in Michigan generally provide a blanket of snow that slows down both vehicle and foot traffic. Plymouth sees its share of the snow. This image shows Main Street looking north, with the Conner Building on the left, probably around 1910.

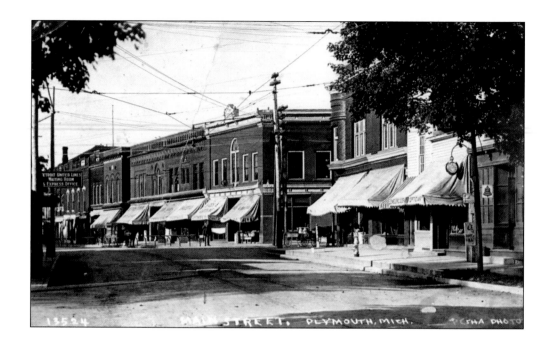

MAIN STREET LOOKING SOUTH OVER TIME. Probably dating to around 1910, this view of the Phoenix Block (above) shows hitching posts, a brick road, and some horse-drawn carriages. The image below can be dated to just after 1920 because the Coleman Building on the corner of Main and Penniman has been replaced with the stately bank building—which doesn't yet have a clock on top. The buildings have very few signs but rely heavily on the canvas awnings to advertise the businesses.

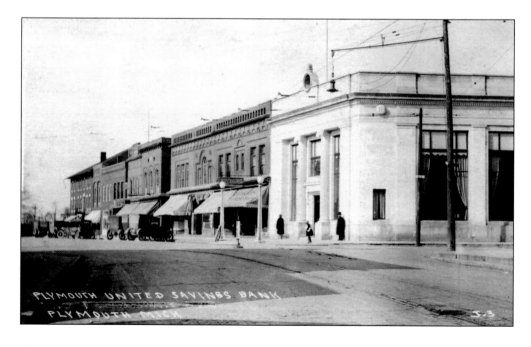

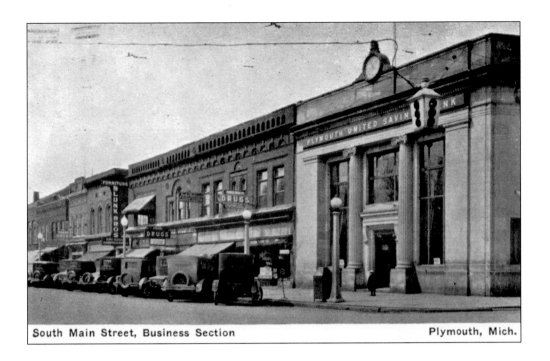

South Main Street, Business Section Plymouth, Mich.

MAIN STREET LOOKING SOUTH OVER TIME. The image that appears above is probably from the mid-1920s, as there's now a clock in the bank building and the business owners have resorted more to signs protruding from buildings. The image below is similar but is probably from 20 years later. The Mayflower Hotel at the far left opened in 1927. D & C 5 and 10 Store opened in the mid-1940s on the corner of Main Street and Ann Arbor Trail (across from the Mayflower Hotel).

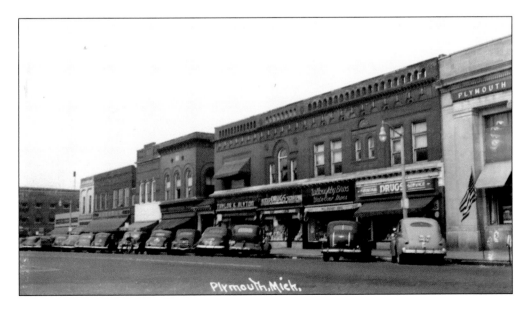

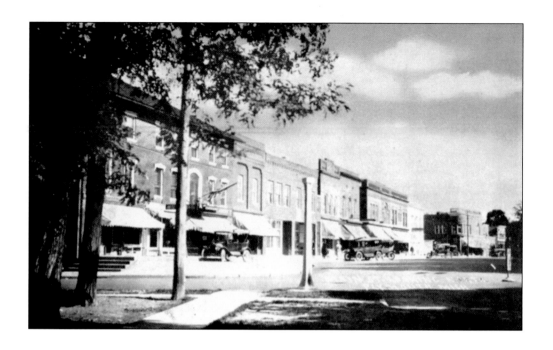

MAIN STREET LOOKING NORTH OVER TIME. This image (above) dates to the mid-1920s, after the bank building was built. D & C Stores Inc. (below) opened on the corner of Ann Arbor Trail and Main Street in the mid-1940s and closed in the 1960s. Kroger opened in its location on Main Street in the 1930s. This image is probably from the 1940s, based on the cars. (Both postcards from the collection of Mike Pappas.)

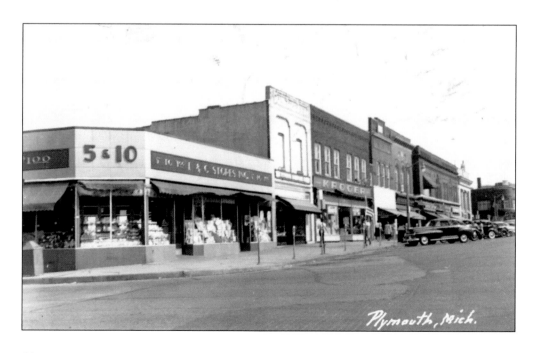

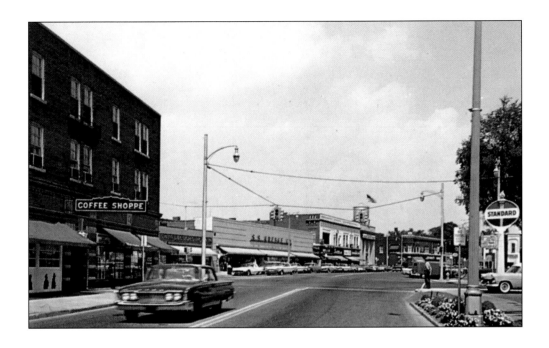

MAIN STREET LOOKING NORTH OVER TIME. Main Street started looking very different in the 1950s when S.S. Kresge Co. tore down half of the Phoenix block for its department store. This image (above) is from the mid-1960s, shortly before D & C Stores closed. By 1980 (below), more stores had received face lifts and Kresge's store had closed to make room for smaller businesses.

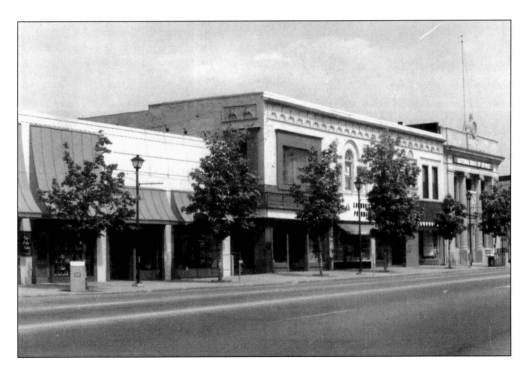

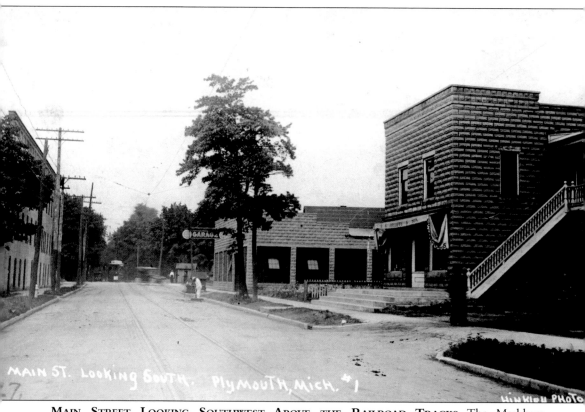

MAIN STREET LOOKING SOUTHWEST ABOVE THE RAILROAD TRACKS. The Markham Manufacturing Company is on the left and Beyer's Garage is across the street. The Markham building still stands and today houses Jack Dunleavy's Restaurant and other commercial enterprises.

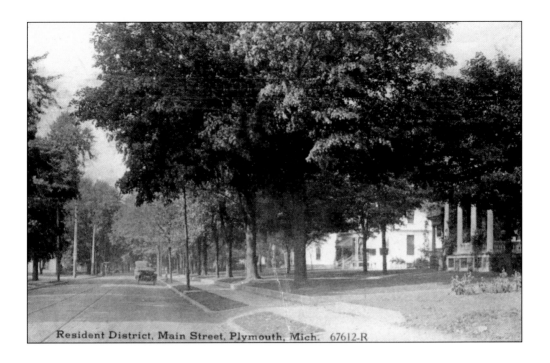

Resident District, Main Street, Plymouth, Mich. 67612-R

RESIDENTIAL DISTRICT OF MAIN STREET. With all of the businesses along Main Street, one would wonder if people lived on the street as well. In its heyday, some of the wealthiest people of Plymouth lived along Main Street. In these images, their stately Victorian homes can be seen.

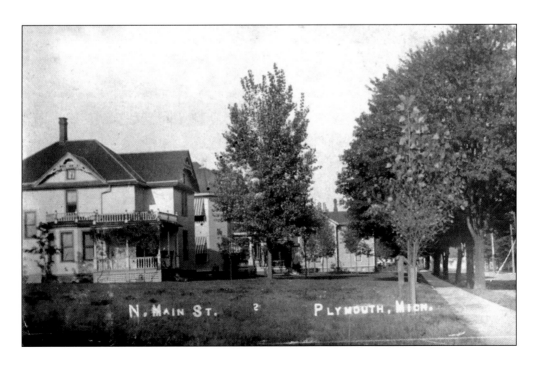

N. MAIN ST. PLYMOUTH, MICH.

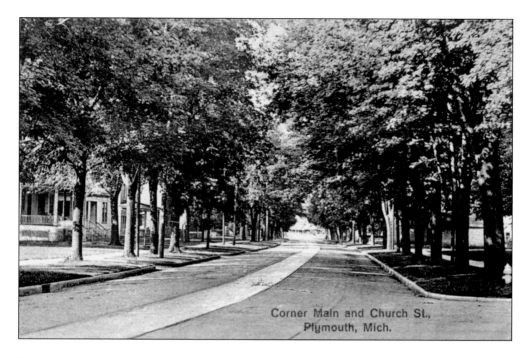

Corner Main and Church St.,
Plymouth, Mich.

LOOKING SOUTH ON MAIN STREET. At the corner of Main and Church streets the tree-lined boulevard was also home to some Plymouth residents. In the image above, the Interurban tracks are still visible. North Main meets South Main at this bend in the road (below), adjacent to a drop-off for students at Plymouth High School. In this later image, it appears that Interurban tracks have been removed. The Interurban stopped running in 1924. (Bottom postcard from the collection of Mike Pappas.)

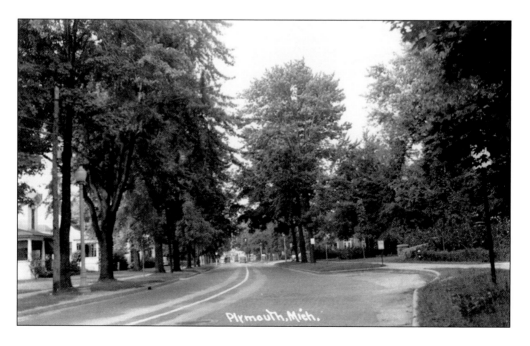

Plymouth, Mich.

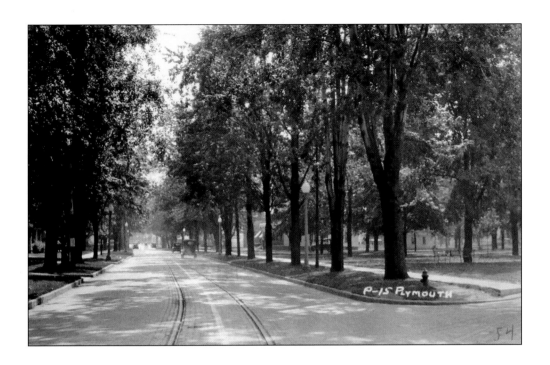

MAIN STREET LOOKING SOUTH. In the postcard above, Church Street is on the right and the view of Main Street looks south toward town, in about 1915. Further north along Main Street, the view below was taken from the corner of Mill Street, before the road was paved. The large home on the left belonged to George Vandecar, a saloon owner and barber.

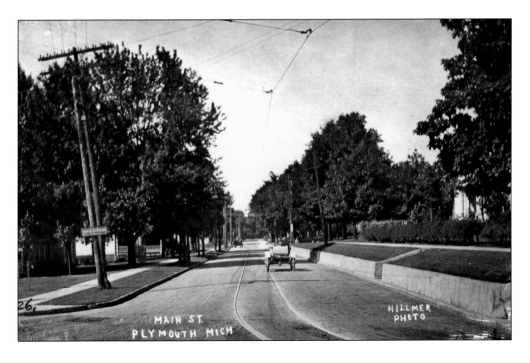

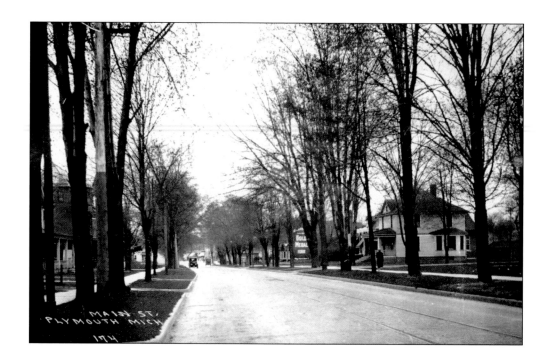

MAIN STREET RESIDENCES. This photo (above) dates from around 1915, based on the brick roads and the hooded autos. In the distance, the awnings of the businesses in the Phoenix block are visible. Note the Gold Medal Flour sign in the center. The photo below of Main Street was taken much earlier, as the road is dirt and there are horse-drawn carriages in the distance. (Top postcard from the collection of Marilyn Detmer; bottom postcard from the collection of Mike Pappas.)

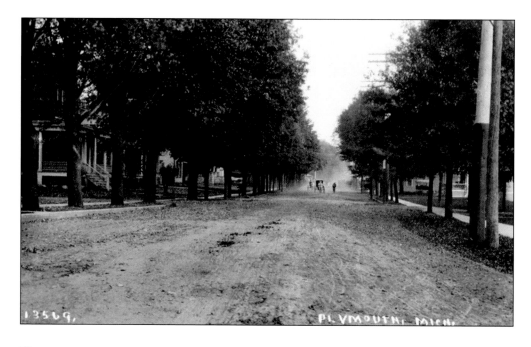

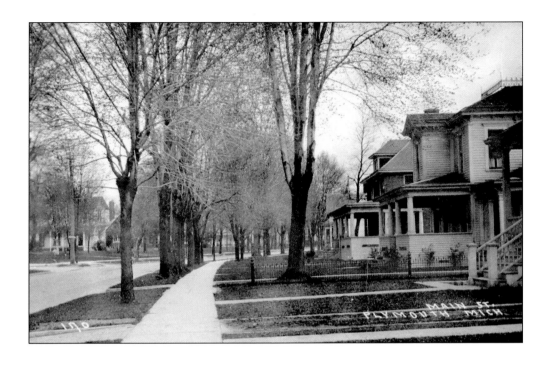

MAIN STREET RESIDENCES. This image (above) depicts Main Street looking north from the edge of town. The bend in the road is the dividing line between North and South Main Street. Many of these houses are no longer standing. The image below is yet another view of North Main Street from the early 1920s, before the Interurban stopped running.

North Main Street Plymouth, Mich.

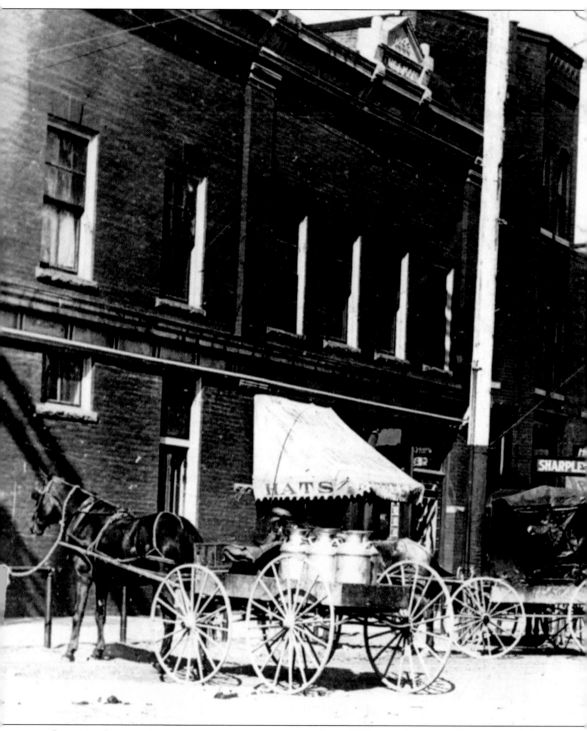

SUTTON STREET LOOKING WEST. This is a snapshot of Plymouth in the first years of the twentieth century. The Coleman Building, built in 1893, is on the left and extends around the corner to Main Street. Huston and Company Hardware is adjacent to the first Plymouth Post

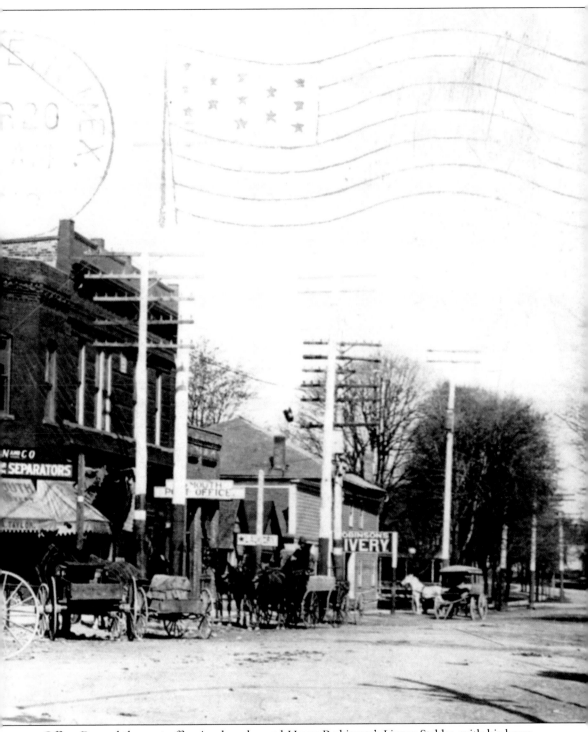

Office. Beyond the post office is a laundry and Harry Robinson's Livery Stables, with his horse-drawn "bus" sitting outside. The road is unpaved, so the photo is from before 1908. Sutton Street was renamed Penniman Avenue in 1912.

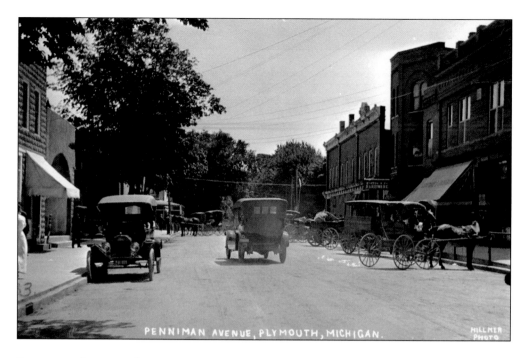

PENNIMAN AVENUE. This is a pre-1920 view of Penniman Avenue looking east toward Kellogg Park (above). Huston Hardware and the Coleman Building are on the right. There is still a significant mix of automobile and horse traffic on the street at this time. In a post-1920 view of the corner Penniman Avenue and Main Street looking west (below), the Plymouth United Savings Bank building with the clock on it is pictured. It was built in 1920, replacing the Coleman Building.

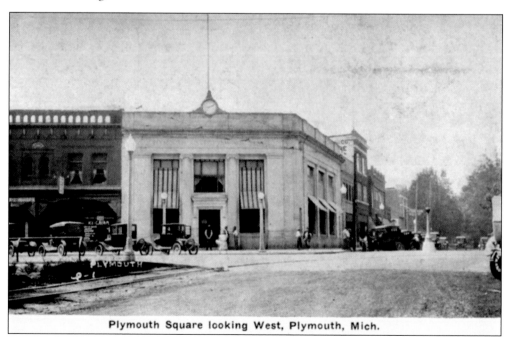

Plymouth Square looking West, Plymouth, Mich.

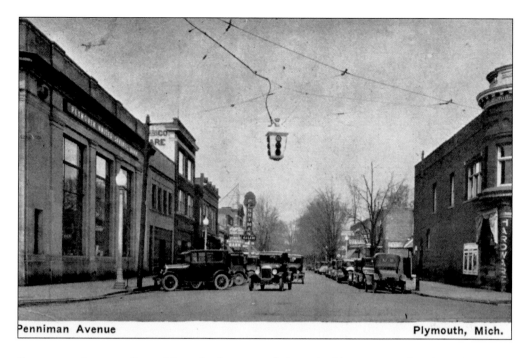

Penniman Avenue
Plymouth, Mich.

PENNIMAN AVENUE OVER TIME. In the postcard above, looking west on Penniman Avenue in the 1920s, some of the same businesses can be seen lining the street, including both Huston (left) and Conner (right) Hardware stores. Kate Penniman Allen built the Penniman-Allen Theater in the distance in 1918. The First National Bank of Plymouth also had an office on Penniman. A similar view of Penniman Avenue appears below, only this one was taken about twenty years later, perhaps in the mid-1940s. By that time the new Post Office building had been built across the street from its former location, and other stores had moved in to fill the vacancy.

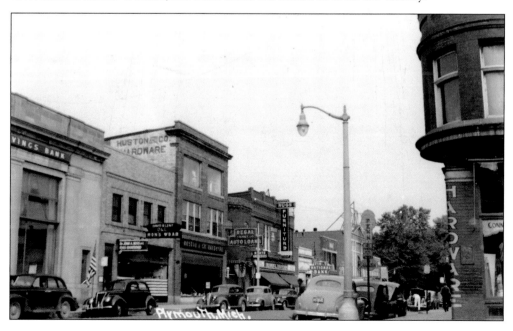

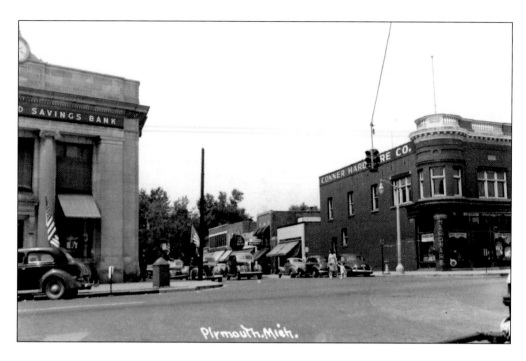

PENNIMAN AVENUE/SUTTON STREET. This image gives a better view than the previous image of the buildings on the north side of Penniman Avenue (above). In the foreground, it's easy to tell where the Interurban tracks had been two decades previously. At the time of this photo, Penniman allowed traffic in both directions. Today it's a one-way street between Harvey and Union streets. Some of the most impressive homes in Plymouth lined Sutton Street/Penniman Avenue, and still do (below).

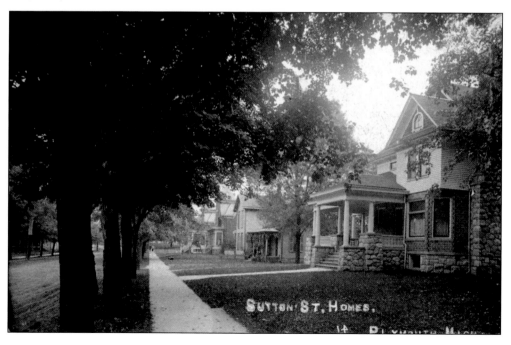

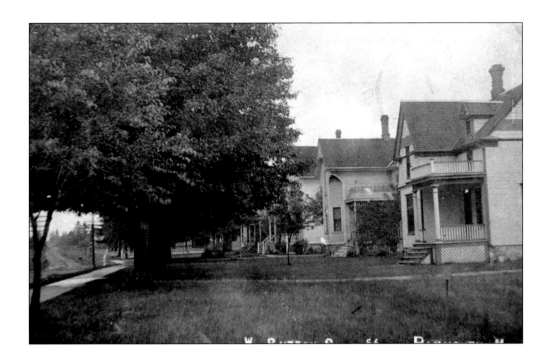

SUTTON STREET/PENNIMAN AVENUE. More Victorian homes can be seen on the north side of Sutton Street before the road bends to the west (above). The other side of Sutton/Penniman is shown below, as it appeared a few years later, but still before the road was paved. Plank sidewalks line the sides of the road. (Bottom postcard from the collection of Joe LaBeau.)

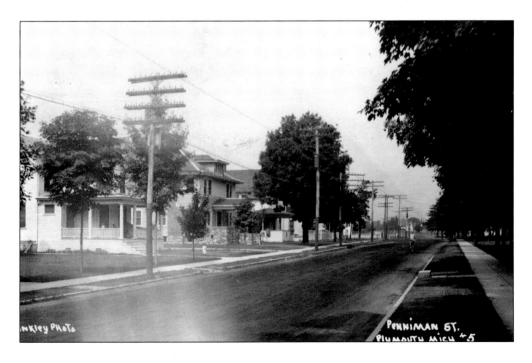

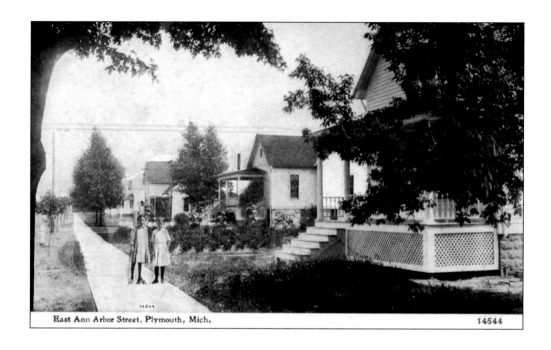

East Ann Arbor Street, Plymouth, Mich. 14544

ANN ARBOR STREET/TRAIL. As seen in the postcard above, the residential portion of Ann Arbor Street (later renamed Ann Arbor Trail) east of town had smaller houses than the Penniman Avenue area. The commercial district of Ann Arbor Trail (below) was thriving with business as much in the 1960s as it is today. The Mayflower Hotel is on the far left and D & C Stores (which closed in the late 1960s) are on the far right.

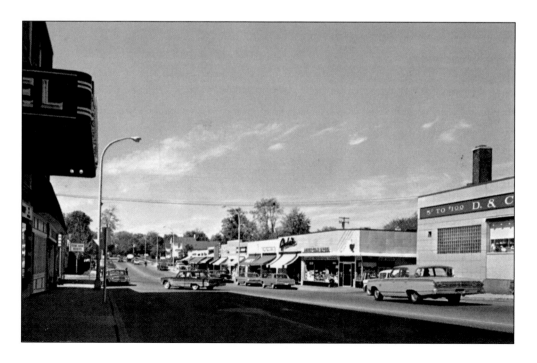

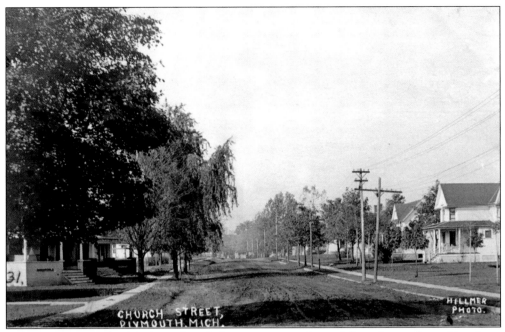

CHURCH STREET. At this time, Church Street ran on a diagonal from Sutton Street/Penniman Avenue straight to Main Street in front of the Plymouth High School. In the mid-1900s, Church Street was rerouted near the high school end and the road now bends in front of the Presbyterian Church to meet Main Street straight-on. A park was created in the front of the high school where the road had been.

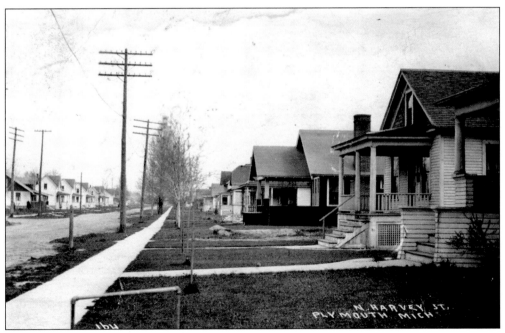

NORTH HARVEY STREET. North Harvey runs parallel and is the first street to the west of Main Street.

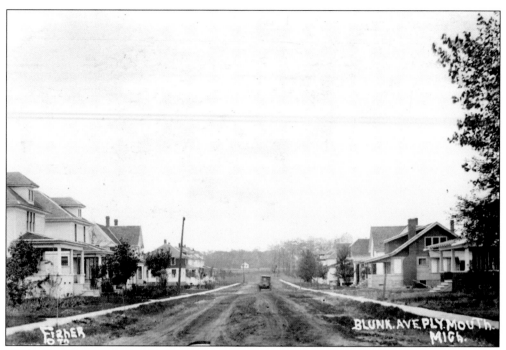

BLUNK STREET. Blunk Street is one of the streets in the Blunk subdivision. Several of the streets in the subdivision were named for Blunk family members, including Irvin, Arthur, Blanche, William, and Ann Streets.

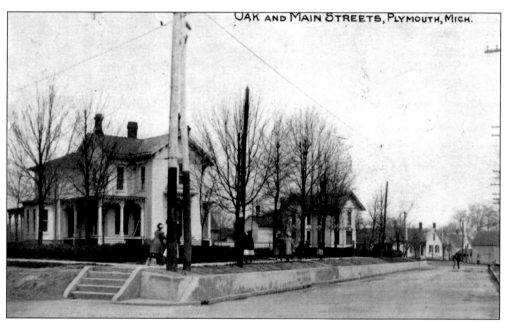

OAK STREET/STARKWEATHER AVENUE. George Starkweather, the first white child born within the confines of what is now the City of Plymouth, owned considerable land northwest of the village. In the 1870s, he put several roads through his property, including Oak Street, which was later renamed Starkweather Avenue. This image shows the corner of Main and Oak Streets.

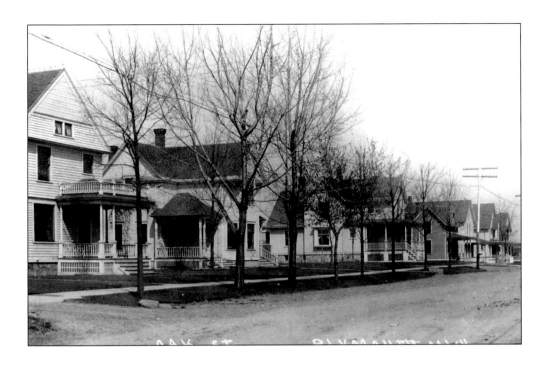

OAK STREET/STARKWEATHER AVENUE. Many stately residences of Victorian vintage line the eastern end of Oak Street/Starkweather Avenue (above). Smaller residences appeared along the western end of Starkweather, near where it joins with Mill Street (below).

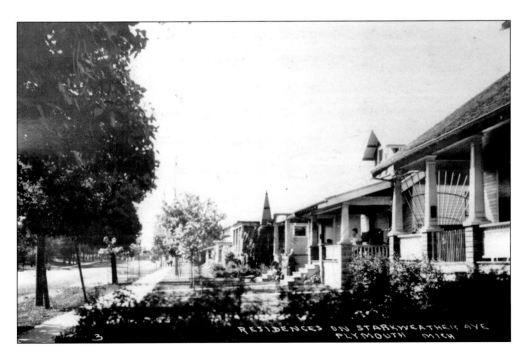

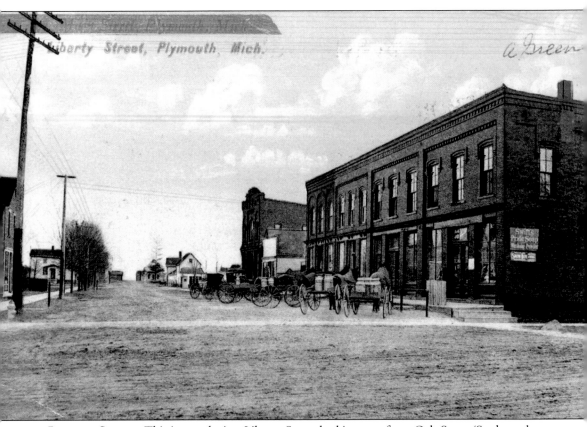

LIBERTY STREET. This image depicts Liberty Street looking east from Oak Street/Starkweather Avenue (in foreground) toward Mill Street. The stores on the right were built in 1871. George Starkweather put Liberty Street and Oak Street through his farm property when the railroads came to Plymouth because he thought this would be the center of business activity. But that never happened.

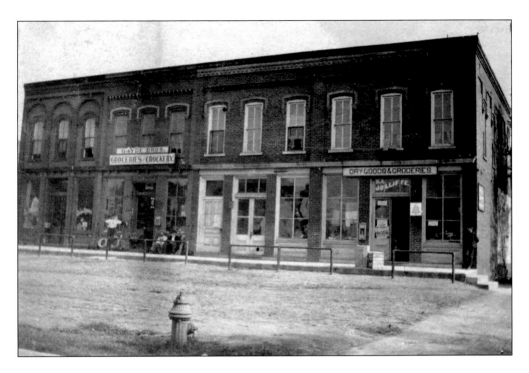

LIBERTY STREET IN THE EARLY 1900S. Peter and William Gayde operated a mercantile business on Liberty Street in Old Village for more than 30 years. The Jolliffe Brothers had one of the most complete general stores in Wayne County. In this view, Oak Street/Starkweather Avenue is on the right (above). An early 1900s view of Liberty Street looking east to west appears below. The buildings on the left still stand today.

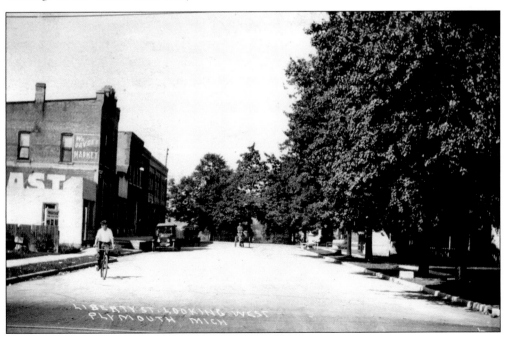

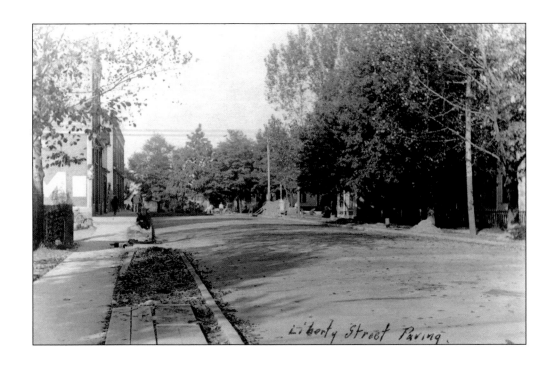

Liberty Street Paving.

LIBERTY STREET. Brick paving of Liberty Street took place between 1910 and 1920, which helped the new automobiles drive better on the roadway. This view looks west from Mill Street toward Oak Street/Starkweather Avenue (above). A 1920s-era view of Liberty Street from Oak Street/Starkweather Avenue looking east appears below. Old Village (where Liberty Street is located) has also been known as North Village and Lower Town over the years. The building on the left was a bank. (Bottom postcard from the collection of Joe LaBeau.)

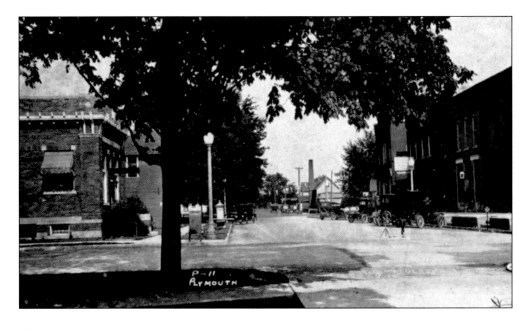

P-11
PLYMOUTH

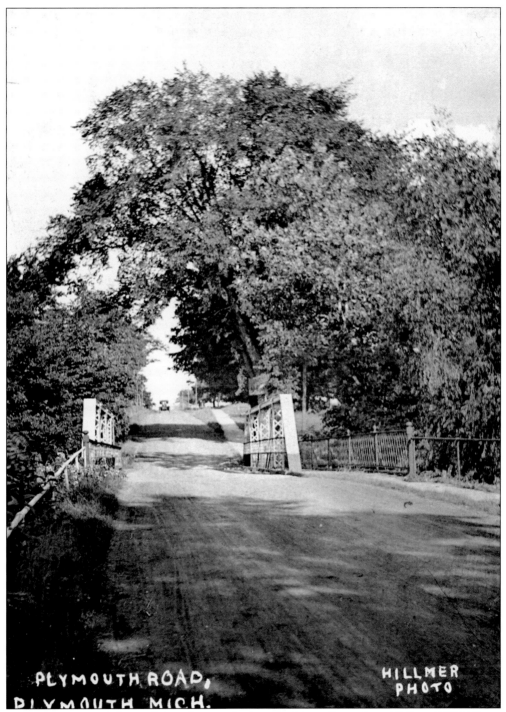

PLYMOUTH ROAD,
PLYMOUTH MICH.

HILLMER
PHOTO

PLYMOUTH ROAD. Plymouth Road was a plank road with a tollgate from 1851 to 1872. Tollgate number 4 stood at the corner of Mill Street and Plymouth Road where it becomes Main Street. This photo dates from between 1910 and 1920, and the bridge spans the Middle Rouge River. Riverside Cemetery is beyond the hill on the right.

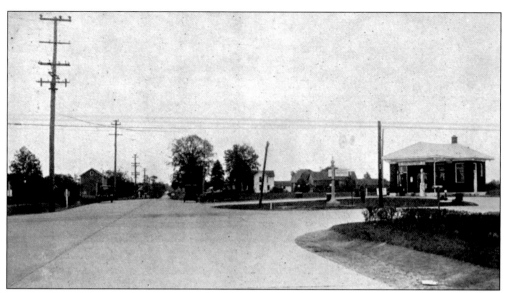

SUPER HIGHWAY. The postcard description says that this road ran between Detroit, Ann Arbor, and Chicago and the view is of Plymouth. However, it is thought that this was actually Michigan Avenue where it intersects with Canton Center Road in the neighboring township of Canton. The road was paved and the gas station was built around 1925.

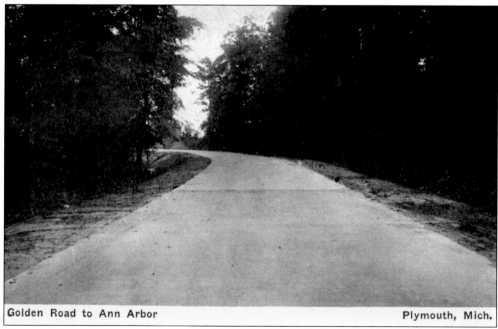

Golden Road to Ann Arbor Plymouth, Mich.

GOLDEN ROAD TO ANN ARBOR. Golden Road received its moniker from the golden sand that was kicked up when vehicles passed over it. It was paved in 1933 and was renamed Ann Arbor Road because it runs between Plymouth and Ann Arbor. Ann Arbor Street within the City of Plymouth was renamed Ann Arbor Trail.

Five

SCENERY

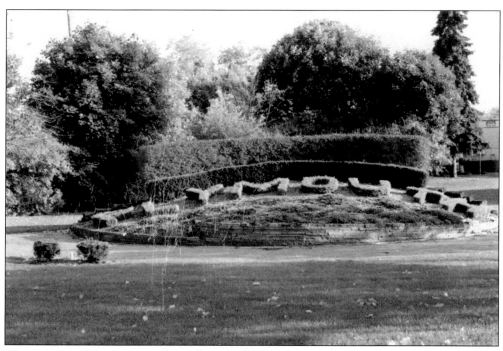

WELCOME TO PLYMOUTH. The park with this "Plymouth" hedge greets visitors to the city where Mill and Starkweather roads split off from Northville Road.

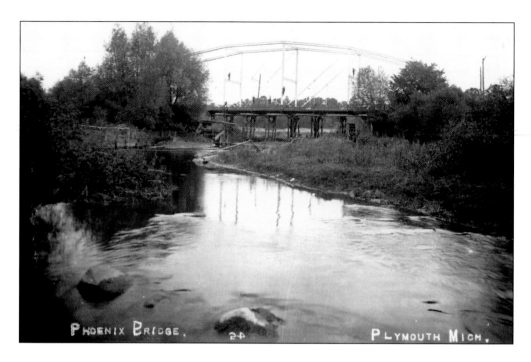

MIDDLE ROUGE RIVER. The Middle Rouge River runs through Plymouth and Plymouth Township and drains eventually into the Detroit River. The Phoenix Bridge (above) spanned the Middle Rouge River with both a bridge for passenger vehicles and a train trestle. Note the people hanging on the bridge supports. The bridge burned down in 1920. Today the bridge that spans the river is made of concrete and is part of Northville Road. Below, workers clean the river bank under the dam on the Middle Rouge River. (Bottom postcard from the collection of Marilyn Detmer.)

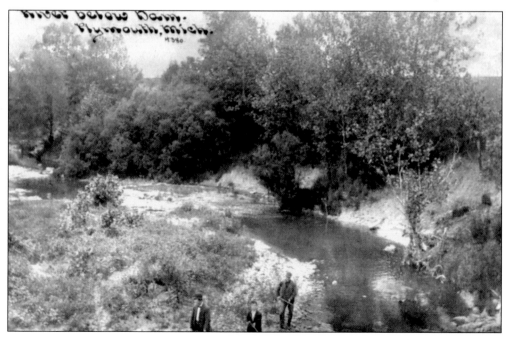

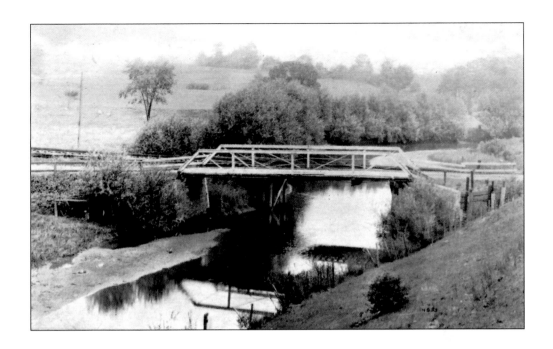

MIDDLE ROUGE RIVER. The bridge that replaced the Phoenix Bridge can be seen above. It was built after the former bridge burned in 1920. The image below provides a view of the Middle Rouge River in Hines Park. The park is the largest park in the Wayne County park system, running 17 miles from Northville (north of Plymouth) to the edge of Detroit.

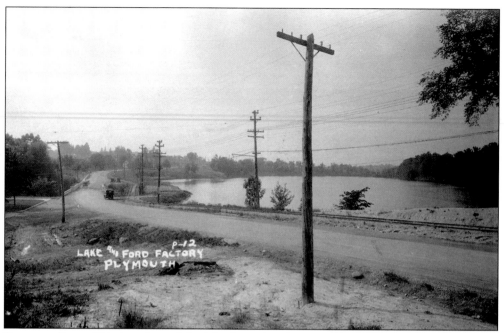

PHOENIX LAKE. This is a view of the lake from the Phoenix Ford Factory, looking north. The road is called Northville Road.

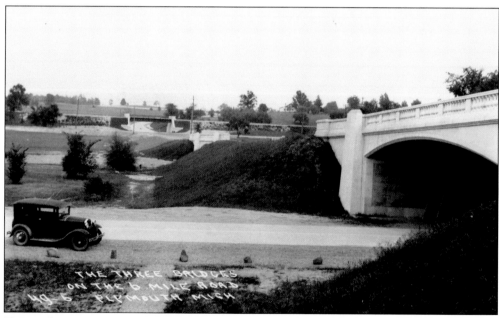

THREE BRIDGES ALONG FIVE MILE ROAD. The road in the foreground is now called Hines Park Drive and goes under the first bridge on Five Mile Road. The second bridge spans the Middle Rouge River and the third bridge carries trains over the road. (Postcard from the collection of Mike Pappas.)

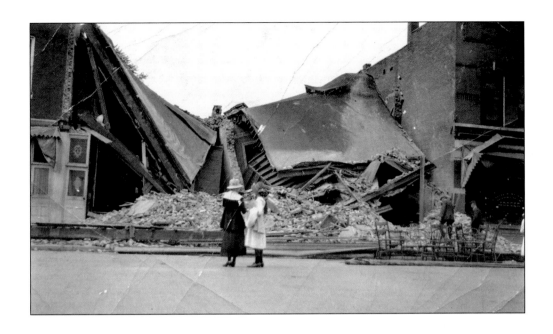

DESTRUCTION. Spectators glance at the damage caused when a roof collapsed on a store along Penniman Avenue (above). The aftermath of a rare tornado in Plymouth Township left victims bewildered (below).

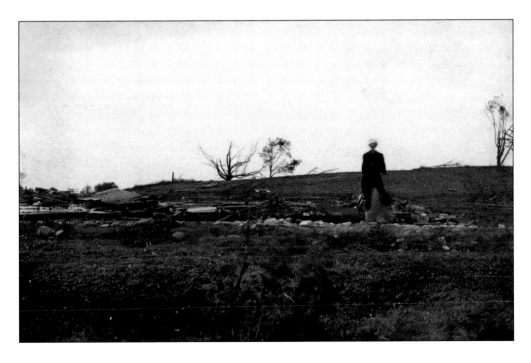

SUGAR BEET FIELD ON PAUL BENNETT FARM. Bennett's house and barn are in the background. The farm was on the corner of Golden (now Ann Arbor Road) and Sheldon roads. The corner now is the home to a gas station and a strip mall.

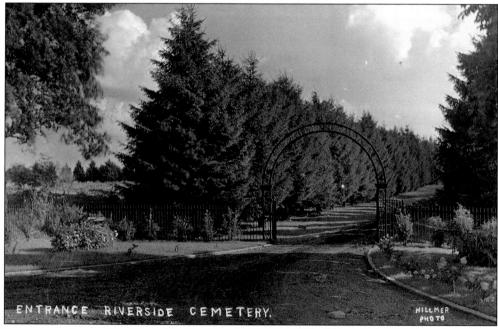

ENTRANCE RIVERSIDE CEMETERY.

HILLMER PHOTO

RIVERSIDE CEMETERY. Riverside Cemetery is located off of Plymouth Road on the eastern edge of the City of Plymouth. It is now the only public cemetery in the Plymouth area. The land for Riverside was purchased by the village for cemetery purposes in 1877 from Franklin and Ellen Shattuck. The village later acquired more acreage adjoining the cemetery.

LOVERS' LANE. That was the local term for this footpath running along Mill Street. After Henry Ford set up his Village Industries plants in the 1920s, this path was used regularly between the Phoenix Mill Plant, which employed only women, and the Wilcox Mill Plant, which employed only men.

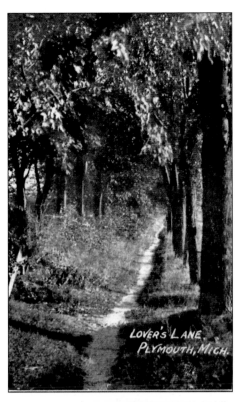

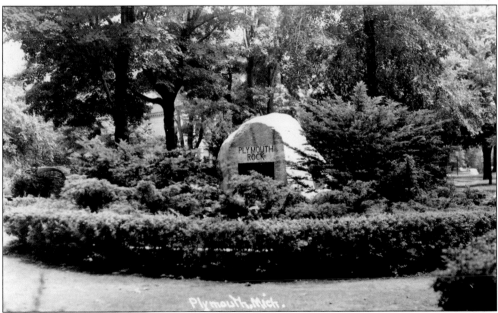

PLYMOUTH ROCK. Plymouth Rock was brought to Plymouth from Plymouth Landing in Massachusetts by a government representative from Plymouth, England. Plymouth, Michigan, is a sister city to both Plymouth, Massachusetts, and Plymouth, England. This rock is located at the apex of Kellogg Park, next to the Wilcox house.

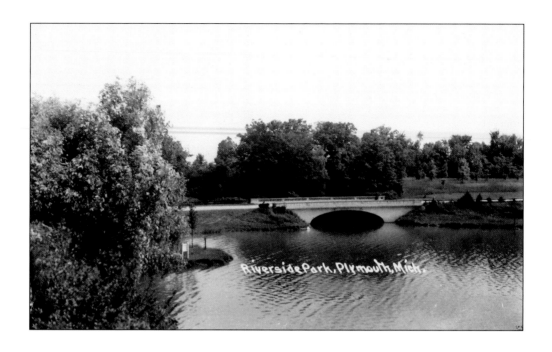

RIVERSIDE PARK. Plymouth's Riverside Park became part of the Middle Rouge Parkway (now Hines Park Drive) in 1929. Riverside Park in Plymouth included Wilcox Lake, Phoenix Lake, and the Middle Rouge River.

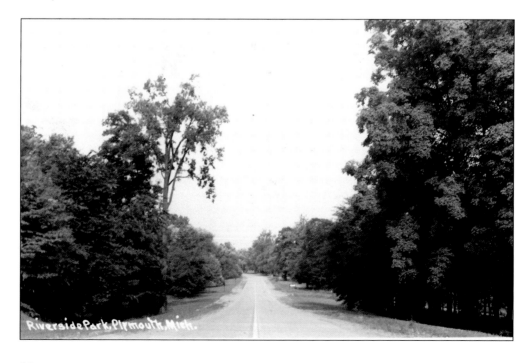

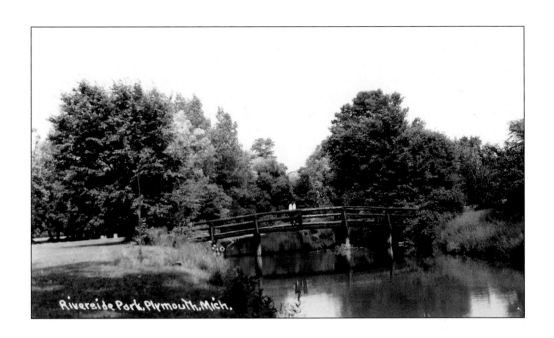

RIVERSIDE PARK. Much of the beauty of Riverside Park has been retained today as part of the long stretch of Hines Park, which runs from Detroit to Northville.

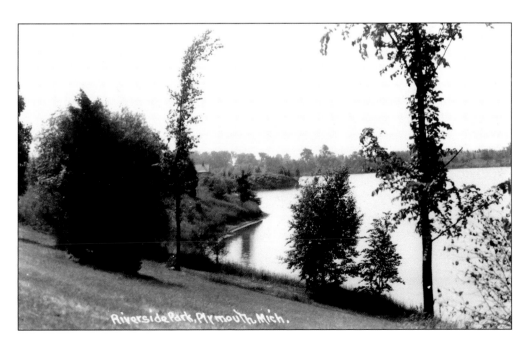

THE BANDSTAND IN PENNIMAN–ALLEN PARK. This bandstand was used for public performances. The park was at the corner of Penniman Avenue and Church Street, where a house stands today. The bandstand was removed in the 1950s.

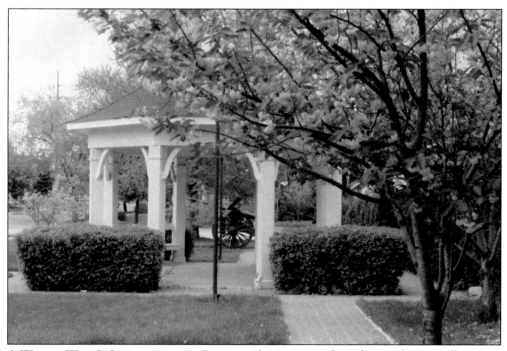

A WORLD WAR I CANNON AND A GAZEBO. The cannon and gazebo stand in a small park on Farmer Street between Mill and Starkweather streets in Plymouth's Old Village. The gazebo is a popular place for weddings in the summertime.

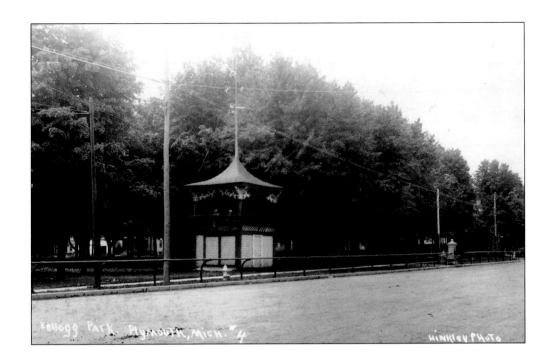

THE BANDSTAND IN KELLOGG PARK. This bandstand was removed in the early 1920s. In later years, bandstands served as mere decorations and were eventually removed. During early days when local talent bands were popular, the stands served a useful purpose. The park has always attracted people on special occasions, such as Gala Day and the current Fall Festival, and for weekend strolls through a quiet park.

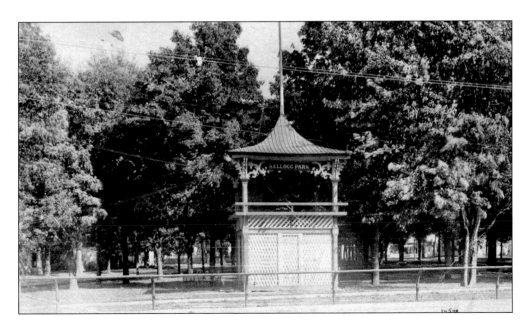

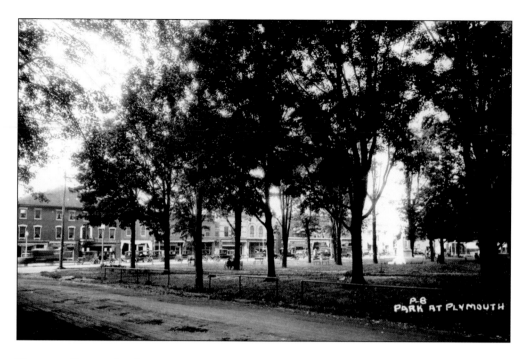

KELLOGG PARK. The above view of Kellogg Park looks northwest from Ann Arbor Street/Trail and probably dates to about 1920, as the new bank building can be seen through the park on Main Street. The monument in Kellogg Park (below) was a temporary structure that commemorated those that went off to World War II from the Plymouth area. It was later torn down and the names of the war dead are on a plaque elsewhere in the park. This image dates to the mid-1940s after the D & C 5 and 10 Store opened on Main Street. The Mayflower Hotel is kitty-corner from the park on the left.

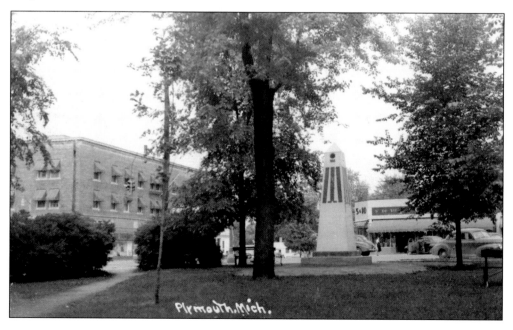

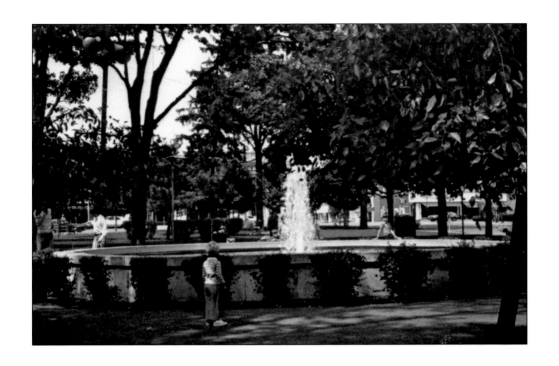

KELLOGG PARK FOUNTAIN. The fountain was added to Kellogg Park in 1969 (above). The fountain's aesthetics were enhanced in the mid-1990s to make it the focal point of the park (right). (Bottom postcard used with permission of Jill Andra Young Photography; from the collection of the author.)

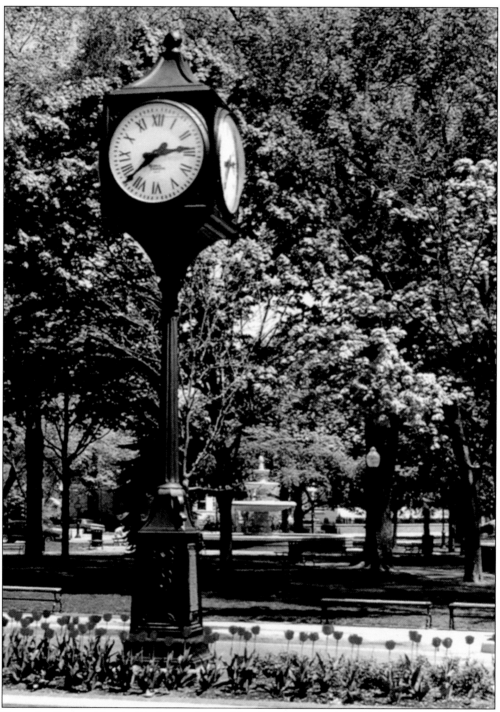

PETER'S CLOCK. Peter's Clock was donated by former mayor Harold Guenther and his wife Geneva in memory of their son, Peter. The clock stands on the Main Street median between Penniman Avenue and Ann Arbor Trail. (Postcard used with permission of Jill Andra Young Photography; from the collection of the author.)

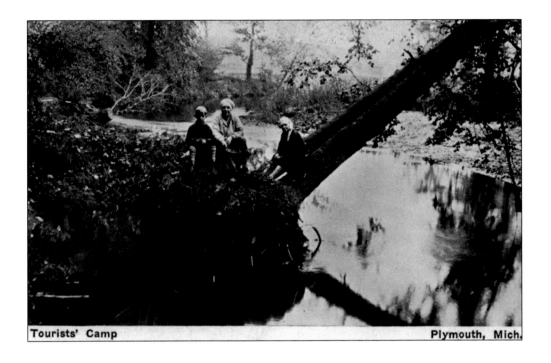

Tourists' Camp Plymouth, Mich.

PLYMOUTH TOURIST CAMP. The Tourist Camp was originally part of the William Henry 110-acre farm that was bounded on the north by Plymouth Road, on the east by Riverside Cemetery, and on the south by Ann Arbor Street. In 1920, a section of the property was sold to the city and was known as the Plymouth Tourist Camp.

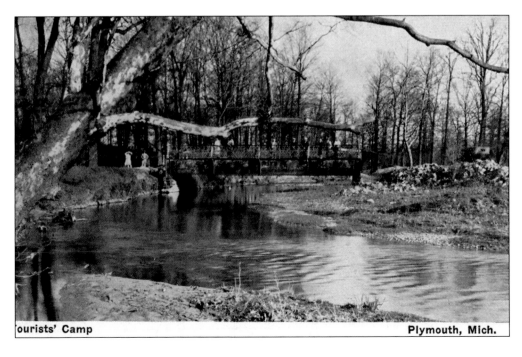

Tourists' Camp Plymouth, Mich.

Plymouth Tourist Camp. The Tourist Camp was renamed Riverside Park, and in 1935 the park was combined with other parcels of land to form the Middle Rouge Parkway (now Hines Park Drive). Phoenix Tourist Camp and Plymouth Tourist Camp were two names for the same property. (Bottom postcard from the collection of Joe LaBeau.)

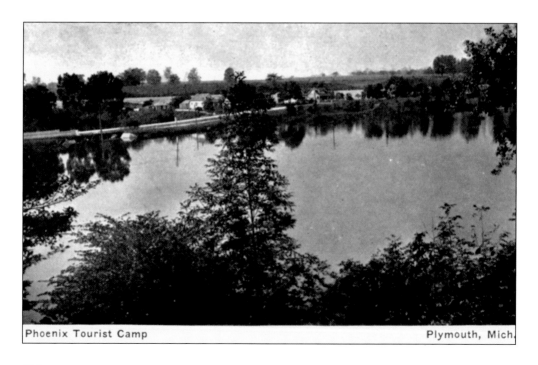

Phoenix Tourist Camp Plymouth, Mich.

Six

PEOPLE

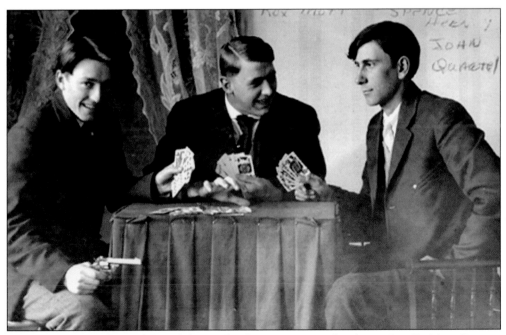

THE OLD WEST? Pictured from left to right, sharing a game of cards, are Roy R. Mott, Spencer James Heeney, and John Quartel Jr.—all 1909 graduates of Plymouth High School. Mott was class president.

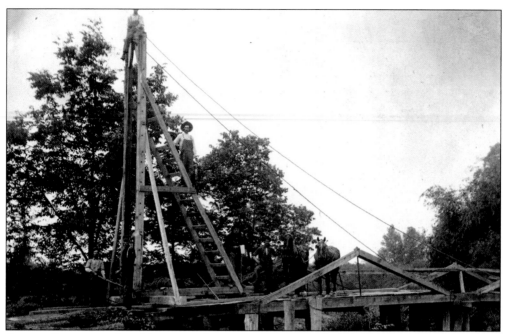

BRIDGE BUILDERS. These laborers work on one of the many bridges that span the Middle Rouge River in Plymouth.

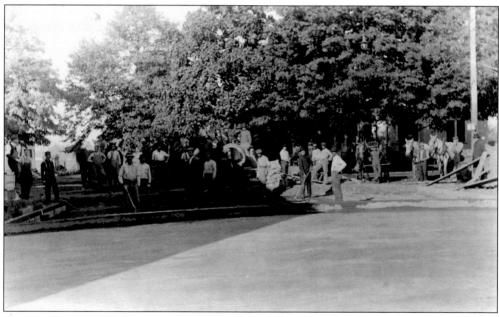

STREET PAVING. Workers prepare the roads and the sidewalks for paving near a park in Plymouth.

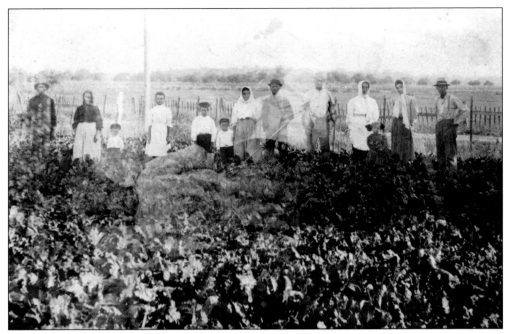

FARM LABORERS. Migrant Hungarian laborers worked the sugar beet fields on Paul Bennett's farm. This is the present-day corner of Ann Arbor and Sheldon Roads.

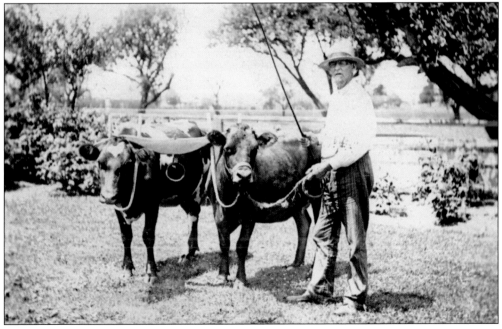

A MAN AND HIS COWS.

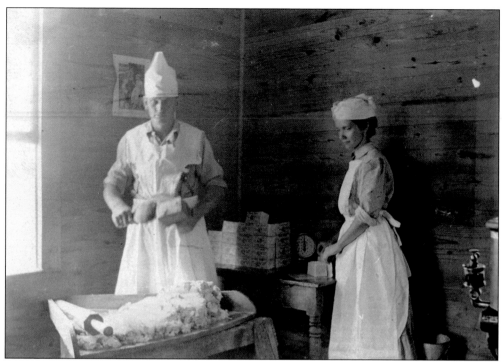

MAKING BUTTER. Norman and Cornelia Miller make butter for resale.

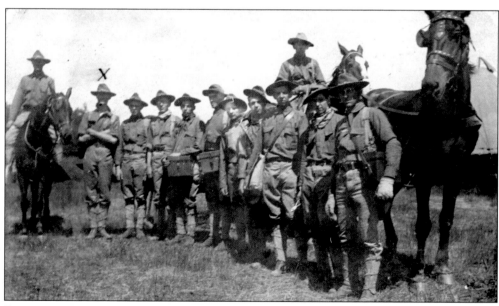

PLYMOUTH RESERVE SIGNAL CORPS. This picture was taken in Ludington, Michigan. Emerson Woods stands under the X.

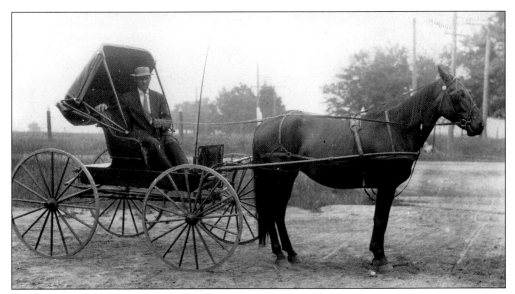

ED BAUMAN. Mr. Bauman poses here in his horse-driven buggy.

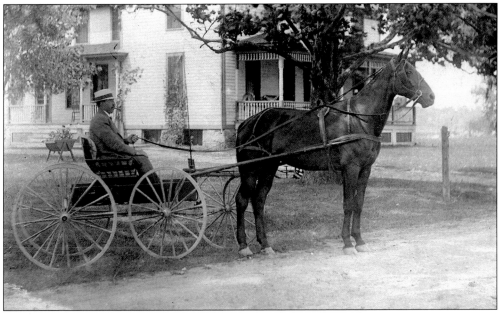

ALBERT ECKLES. Mr. Eckles pauses in front of his Plymouth Township home. (From the collection of Betty Barbour.)

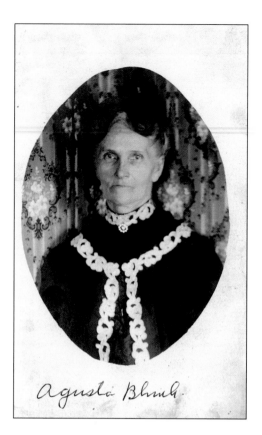

agusta Blunk.

AGUSTA GRIBLY BLUNK. Agusta Blunk was born April 14, 1853 and died July 29, 1909. One of the streets in Plymouth is named for this family.

PLYMOUTH
P-10

PHOENIX FORD PLANT. Some women from the all-female work force at the Phoenix Mill Ford Plant pose near Phoenix Lake, across the street from the plant.

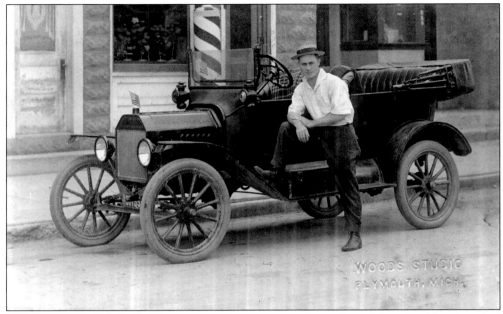

NICE CAR. While the driver is unknown, the car is an early Ford Model T. The driver is parked on Liberty Street in Old Village. (Postcard from the collection of Leora Norgrove.)

THOMAS HOOD. Thomas Hood was born December 9, 1837.

HELEN HUMPHRIES. Helen was the daughter of George E. and Edna P. Van Orman Humphries. She was born March 2, 1911 and died of pneumonia on March 6, 1920.

PLYMOUTH CHILDREN.

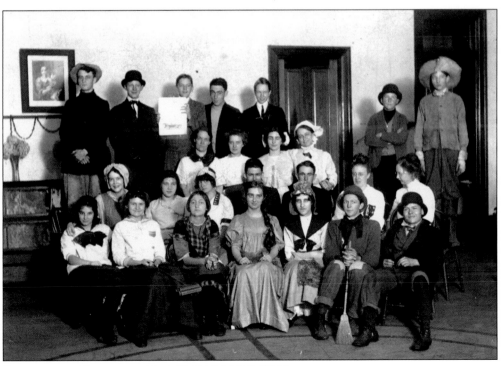

STUDENTS IN COSTUME FOR A HIGH SCHOOL PLAY.

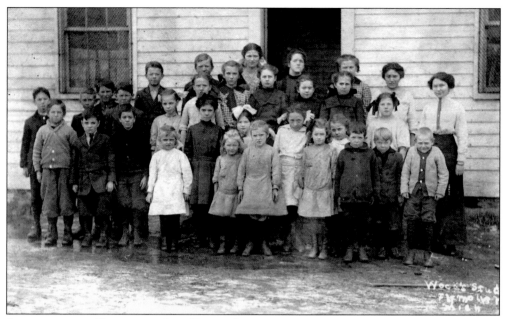

STUDENTS AT A PLYMOUTH ONE-ROOM SCHOOLHOUSE.

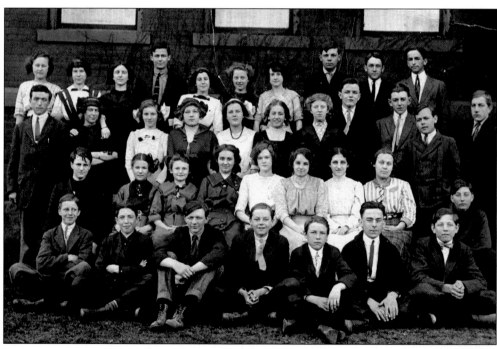

STUDENTS. Pictured from left to right are: (front row) Egbert Isbell, unknown, John Jones, Harold Soop, unknown, Pete Penney, unknown, and Harvey Kolmitz; (second row) Donald Ladd, unknown, Ellen Gardner, unknown, Hilda Smye, Helen Gayde, unknown, and Mary Hill; (third row) unknown, Ada Peck, unknown, Florence McCloud, Faye Ryder, Mildred Tyler, unknown, Davis Hillmer, Howard Berdan, Fred Mack, and Herald Hamill; (back row) unknown, Marjorie Marshall, Roxie Jones, Reiman, Margaret Stevens, next four unknown, and Ross Gates.

Seven

RECREATION

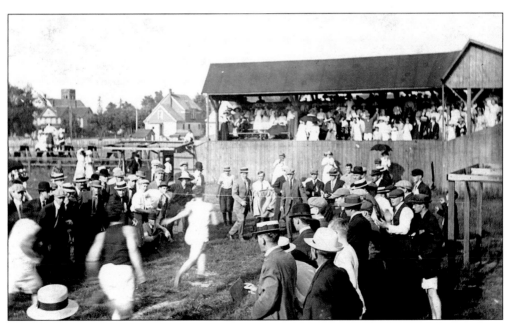

AND THE WINNER IS... A foot race at Plymouth field behind the high school draws a large spectator crowd.

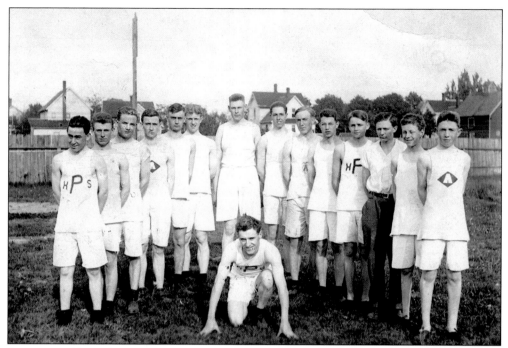

PLYMOUTH HIGH SCHOOL TRACK. Pictured from left to right are Russel Penney, Leo Spencer, Leslie Hudd, Milton Wiseley, Myron Beals, Floyd Bennett, Dale Jones, Harvey Springer, Clyde Whitaker, George Burr, John Jones, Egbert Isbell, and Irwin Grimm. Harold Jolliffe is kneeling in the center. Most students were in the class of 1914.

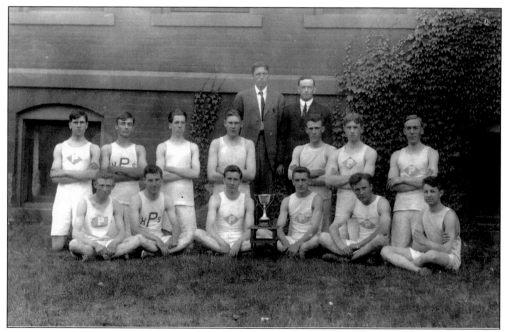

PLYMOUTH HIGH SCHOOL TRACK. The victors show off their trophy. Their names are unknown.

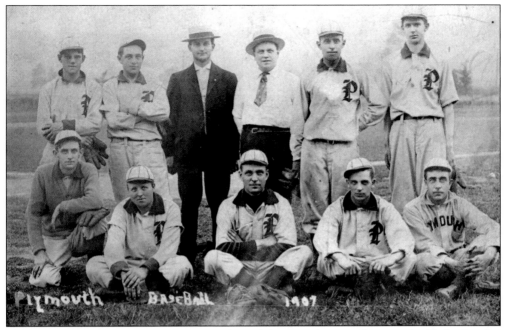

PLYMOUTH BASEBALL CLUB. Pictured from left to right are: (front row) Clyde Bentley, Tomlinson, Curtis, Smith, and Joe Hantz; (back row) George McLaren, Rathburn (manager), Ed Riggs (owner), Claude Henderson, and Frank Toncray.

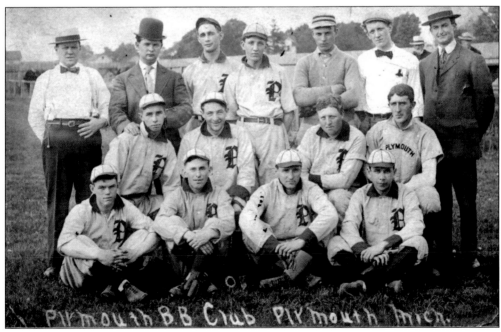

PLYMOUTH BASEBALL CLUB. Pictured in the back row, at left, is owner Ed Riggs.

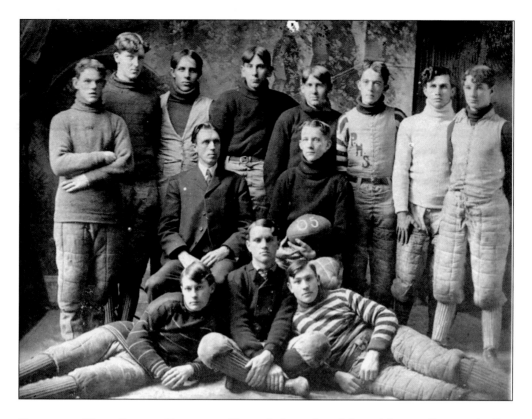

PLYMOUTH HIGH SCHOOL FOOTBALL. Pictured above, from left to right, are: (front row) Allen Wherry, Frank Spicer, and Johnny Burch; (seated) Professor Walter Isbell and Robert Jolliffe; (back row) George McLaren, Howard Brown, Scott Cortright, John Quartel Jr., Roy Mott, Tom Leith, Cady Hix, and Russell Warner. The names of the football players in the image below are unknown.

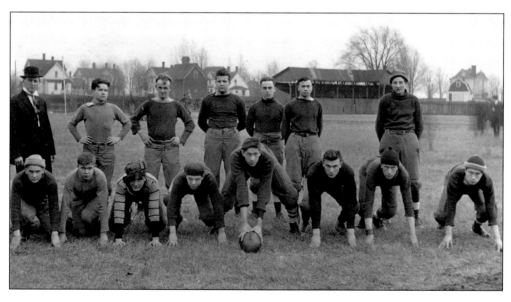

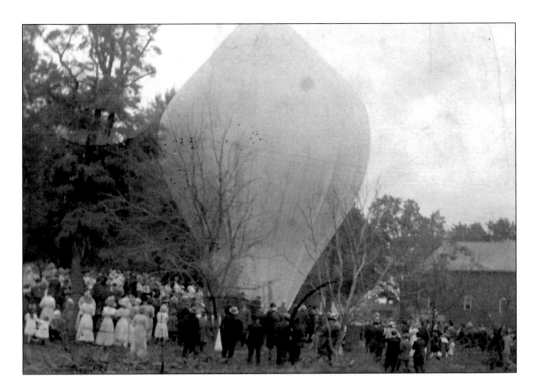

HOT AIR BALLOONS. The balloon rides (above) were a popular attraction at the Plymouth Fair, held annually from 1885 until 1904. During the winter following the 1903 fair, the main building, Floral Hall, was destroyed by fire and was not rebuilt. In 1904, the weather was bad and attendance was down. Consequently, the fair was never held again. Hot air balloons returned to Plymouth for the Balloon Fest in the 1980s (below). While popular, the high cost of insurance brought an end to the festival here.

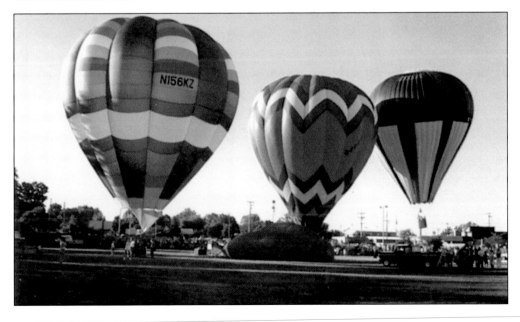

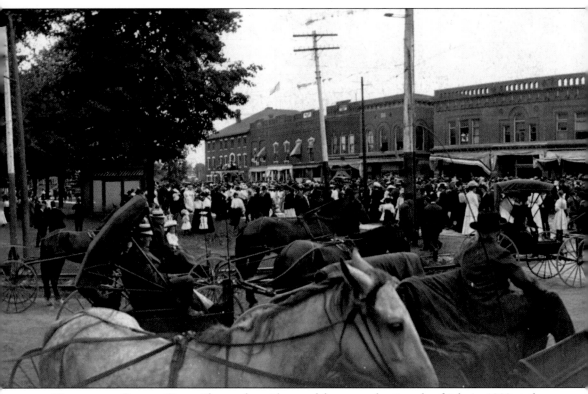

HORSE AND BUGGY DAYS. Plymouth residents celebrate on the Fourth of July in 1909 at the corners of Main Street and Sutton Street (later Penniman Avenue). Kellogg Park is on the left of

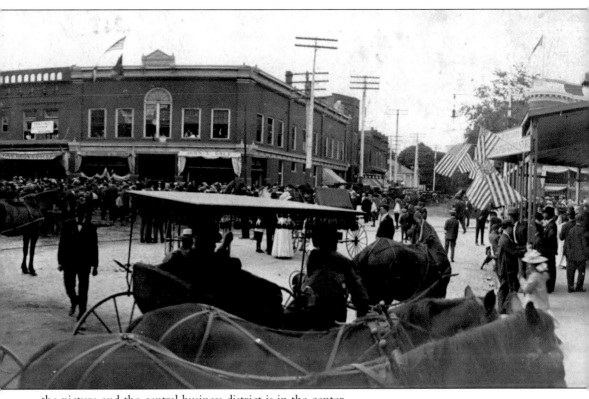

the picture and the central business district is in the center.

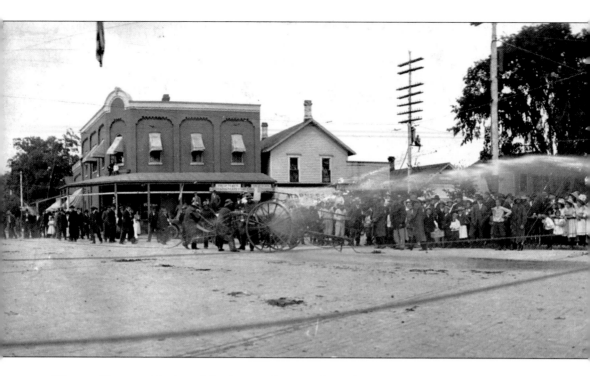

WATER BATTLE. During Gala Day each year, the Volunteer Fire Department made the competition for best hose team into a spectator sport. The photo above faces the northeast corner

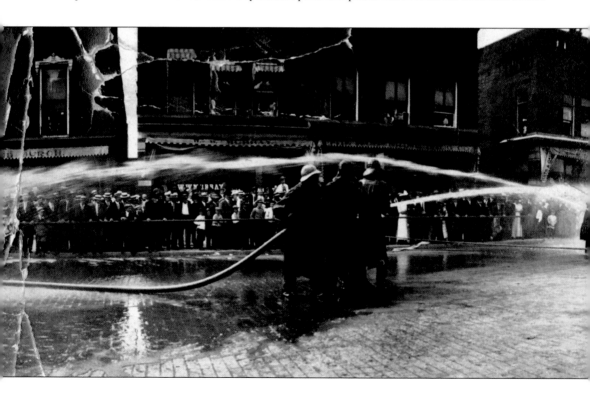

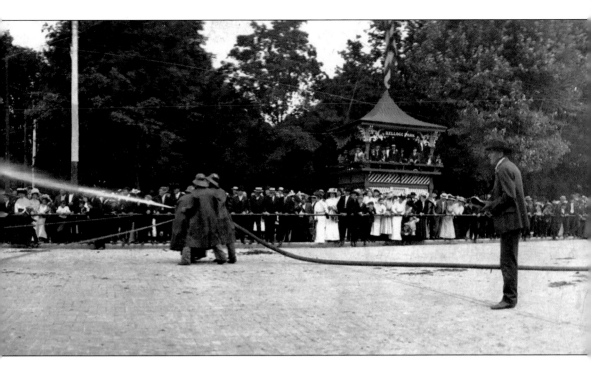

of Main Street and Penniman Avenue, as well as Kellogg Park. The photo below is looking north on Main Street from Ann Arbor Trail.

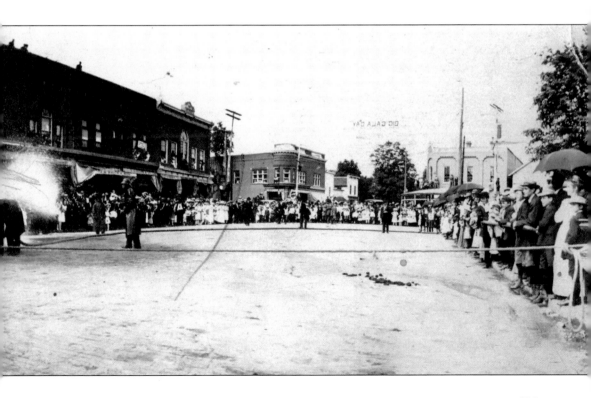

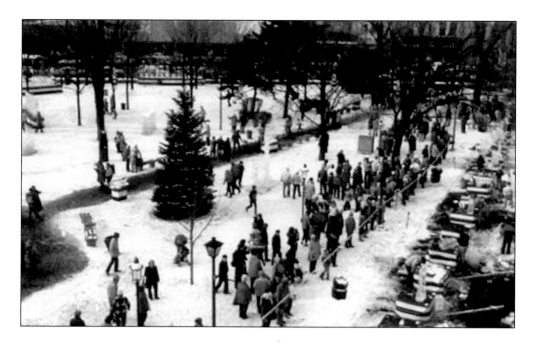

ICE FESTIVAL. Each January for more than two decades, thousands of people have flocked to Plymouth for the annual Plymouth International Ice Sculpture Spectacular. The 2003 festival featured a professional team of world-class carvers from Japan, as well as the largest contingent of student carving exhibitions and competitions in America. Plymouth is known as the birth place of modern ice carving in the United States. (Bottom postcard used with permission of photographer Gerry Jablonski.)

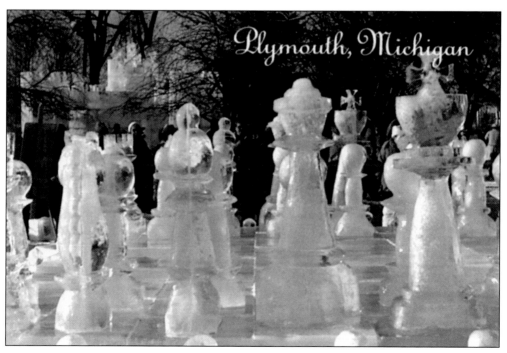

INDEX

Allen
 Kate Penniman 26, 38, 77
 W.O. 26
Allor, Jim 2
Alter
 Clarence 23
 Motor Car Company 23
Ann Arbor
 Road 88, 94, 107
 Street 80, 88, 100, 103
 Trail 30, 52, 65, 66, 80, 88, 100, 102, 123
Archdiocese of Detroit 53, 54
Arthur Street 50
Baker
 Henry 36
 House 36
Balloon Fest 119
Baptist Church, First 49, 51, 52
Barbour, Betty 109
Bauman, Ed 109
Beals, Myron 116
Bennett
 Floyd 116
 Paul 34, 94, 107
 Sewell 34
Bentley, Clyde 117
Berdan
 Charlie 26
 Howard 114
 Marvin 44

Beyer
 Family 36
 Garage 68
Bird, Larry 27
Blunk
 Agusta Gribly 110
 Ann 82
 Arthur 82
 Blanche 82
 Irvin 82
 Street 82
 William 82
Bodes Restaurant 31
Brown, Howard 118
Burch, Johnny 118
Burr, George 116
Burroughs Adding Machine Company 33
Catholic Church
 Our Lady of Good Counsel 38, 50
 St. Michael's 52
Central Middle School 44, 47
Central Park 58
 See also Kellogg Park
Christian Science Church 40, 52
Church Street 37, 44, 49, 70, 71, 81, 98
Coleman Building 64, 74, 76
Conner Hardware 61, 63, 77
Cortright, Scott 118
Curtis 117
D&C Stores 65, 66, 67, 80, 100

Daisy Manufacturing Company 16, 17, 36
Detmer, Marilyn 72
Detroit Creamery Company 24
Detroit, Plymouth & Northville Railroad
 See Interurban
Dodge Street 50
Draper, C.G. 26
Dunleavy's Restaurant 68
Early American Shop 30
Eckles, Albert 109
Eddy, Gordon 31
Ernesto's 31
Erps, Marilyn 6
Evergreen Street 51
Fall Festival 99
Farmer Street 98
First National Bank of Plymouth 77
Five Mile Road 53, 92
Ford
 Henry 18, 19, 95
 Phoenix Plant 19, 95, 110
 Village Industries 95
 Wilcox Plant 18, 95
Gabriela's 27
Gala Day 99, 122
Gardner, Ellen 114
Gates, Ross 114
Gayde
 Family 37
 Helen 114
 Peter 85
 William 85
Golden Road 88, 94
Grimm, Irwin 116
Guenther
 Geneva 102
 Harold 102
 Peter 102
Hamilton Manufacturing Company 16
Hammill, Herald 114
Hantz, Joe 117
Harvey Street 30, 78, 81
Heeney, Spencer James 105
Heide's Flowers 30
Henry, William 103
Hill, Mary 114
Hillmer, Davis 114
Hillside Inn 31
Hines Park 91, 97
Hines Park Drive 104
Hix, Cady 118
Holbrook, Henry 18

Hood, Thomas 111
Hotel Anderine 20
Hotel Victor 20
Hough
 L.C. 25
 Mariette 42
Hudd, Leslie 116
Huffman, Hazel 35
Humphries
 Edna P. Van Orman 112
 Edward 112
 Helen 112
Huston & Company Hardware 74, 76, 77
International Milk Products Company 24
Interurban 14, 57, 62, 63, 70, 73, 78
Isbell
 Egbert 114, 116
 Walter 118
Jablonsky, Gerry 124
Jolliffe
 Brothers 85
 Daniel A. 36
 Harold 116
 Robert 118
Jones
 Dale 116
 John 114, 116
 Roxie 114
Journey Bodywork and Spa 30
Karrer, Janice 6
Kellogg
 John 58
 Park 28, 41, 76, 95, 99, 100, 101, 120, 123
Kenny, Charlene 6
Kerstens
 Helen 6
 Marty 6
King Manufacturing Company 16
Kolmitz, Harvey 114
Kroger Store 66
LaBeau, Joe 18, 79, 86, 104
Ladd, Donald 114
Laible
 Bea 6
 Graham 6
Lapham, Andrew Jackson 29
Leith, Tom 118
Liberty Street 84, 85, 86, 111
Lover's Lane 95
Lower Town 86
Lush, Harry 28
Lutheran Church, St. Peter's Evangelical 51

Mack, Fred 114
Main Street 15, 26, 30, 31, 35, 52, 55, 56, 57, 60, 61, 63, 64, 65, 66, 67, 68, 69, 71, 72, 73, 76, 81, 82, 100, 102, 120, 122, 123
Mansfield, Steve 30
Markham
 Air Rifle Company 16, 38, 68
 Park 39
 William F. 38, 39
Marshall, Marjorie 114
Masonic Temple 43
Mayflower Hotel 21, 22, 65, 80, 100
McCloud, Florence 114
McLaren
 George 117, 118
 J.D. & Company 25
 John J. 25
Methodist Episcopal Church 46, 48
Middle Rouge
 Parkway 104
 River 87, 90, 91, 92, 96, 106
Mill Street 36, 52, 71, 83, 84, 86, 87, 89, 95, 98
Miller
 Cornelia 108
 Norman 108
Montgomery, Charles 31
Mooney, Cardinal 53, 54
Mott, Roy R. 105, 118
Nelson Hotel 20
Norgrove, Leora 111
North Territorial Road 48, 52
North Village 86
Northville Road 89, 90, 92
Oak Street 82, 83, 84, 85, 86
Old Village 85, 86, 98, 111
Old Village Inn 20
 Packer
 Dan 6
 Lena 6
Pappas, Mike 21, 41, 52, 56, 66, 70, 72, 92
Peck, Ada 114
Penn Theater 28
Penney
 Pete 114
 Russel 116
Penniman Avenue 28, 41, 50, 51, 57, 64, 74, 76, 77, 78, 79, 80, 81, 93, 102, 120, 122.
 See also Sutton Street
 Ebenezer Jenckes 38, 44, 50

Penniman-Allen
 Park 98
 Theater 28, 77
Pere Marquette
 Bridge 13
 Depot 9, 10, 29
 Railroad Yards 11
 Round House 11
 Trains 12, 13, 14
Phoenix
 Bridge 19, 90, 91
 Lake 96, 110
 Mill 19
 Tourist Camp 104
Pierce, Frank 10
Plymouth
 & Northville Gas Company 25
 Air Rifle Company 16
 Baseball Club 117
 City Hall 40
 Creamery Company 24
 Fair 119
 Fire Department 40
 Gathering 41, 43
 High School 44, 45, 46, 47, 48, 70, 81, 105, 116, 118
 Hilton 32
 Historical Museum 6, 8, 23, 42
 Hotel 56
 International Ice Sculpture Spectacular 124
 Mail 28
 Mills 18
 Opera House 40
 Reserve Signal Corps 108
 Road 31, 33, 87, 94, 103
 Rock 95
 Rock Lodge #47 43
 Tourist Camp 103, 104
 United Savings Bank 76
 Village Hall 40
 Windmill Company 17
Polly, Anson 42
Post Office 41, 74, 77
Powell, Matthew 24
Presbyterian Church, First 49, 81
Quartel, John Jr. 105, 118
Rathburn 117
Reiman 114
Riggs, Ed 117
Riverside
 Cemetery 87, 94, 103
 Park 96, 97, 104

Robinson
 Harry 56
 Livery Stables 74
 Henry 10
Ryder, Faye 114
S.S. Kresage Company 67
Sambrone Family 20
Schryer, Howard 6
Shattuck
 Ellen 94
 Franklin 94
Sheldon
 Barn Raisers 6
 Road 33, 53, 94, 107
Sheridan Avenue 43
Smith 117
Smith, Dan 29
Smye, Hilda 114
Solid Rock Bible Church 48
Soop, Harold 114
Spencer, Leo 116
Spicer, Frank 118
Springer, Harvey 116
St. John's Provincial Seminary 53, 54
Starkweather
 Avenue 82, 83, 84, 85, 86, 89, 98
 George 82, 84
Stevens, Margaret 114
Stewart, Beth 6

Stremich, Jacob 31
Streng, Margaret 31
Sutton Street 57, 61, 62, 74, 78, 79, 120
 See also Penniman Avenue
Thunderbird Inn 32
Tomlinson 117
Toncray, Frank 117
Tonquish Creek Manor 43
Tyler, Mildred 114
Union Street 50, 78
Universalist Church 50
Vandecar, George 71
Veterans Community Center 42
Warner, Russell 118
West Brothers Inc. 23
Western Electric Company 33
Wherry, Allen 118
Whitaker, Clyde 116
Wilcox
 Family 39
 George Henry 38
 House 38, 95
 Jack 38
 Lake 96
 Mills 18
Wiltse Pharmacy 27
Wiseley, Milton 116
Woods, Emerson 108
Young, Jill Andra 101, 102